Boatview, Castara Colouring Book

It is well documented that, for many people (adults and children alike), colouring is a therapeutic, stress-relieving pastime.

What could be better, then, than colouring pictures of your favourite holiday spot? While away the hours dreaming of being (back) in Tobago, sunning yourself on the fine golden sand, bathing and snorkelling in the crystal clear blue Caribbean Sea, or enjoying a rum punch on the deck of the Boathouse Restaurant as the sun goes down.

If you have visited before, within these pages you will find familiar scenes and people waiting to welcome you back. If you haven't been here yet, these pictures are designed to encourage you to get on that flight to sunny Tobago!

Unlike most other colouring books which are usually filled with whimsical and cartoon images, mine are full of real pictures.

In this case, the colouring pages were created from photographs I took during our first four-month stay with Brenton and Sharon Taylor in Castara. We spent our time getting to know the people and learning about Tobago's rich history and culture. Within this book, you will find images of the Boathouse Bar and Restaurant, views of Little Bay from the decks of the Boatview Apartments, shots of the bar's colourful ceiling, and pictures of the staff and the dogs, Jemima and Shrek. There are drawings here to inspire you and get your creative juices flowing!!

Grab your favourite pens or pencils and let your imagination and creativity run riot. I use high quality fine-tip felt pens for the details, and coloured pencils for the larger areas, but the choice is yours. Some people like to put a water colour wash across the whole picture before they begin. It's your creation. It's up to you!

Cut out your finished work and display it somewhere as in inspiration to travel further for longer, or as a reminder of places you've already been to.

Keep in touch with me at Happy Days Travel Blog or on social media:

@happydaystravelblog @happydayswriter

Show me your creations, follow my travels, and tell me about yours!

Copyright © 2019 Happy Days Publishing - All Rights Reserved. Further information from https://happydaystravelblog.com

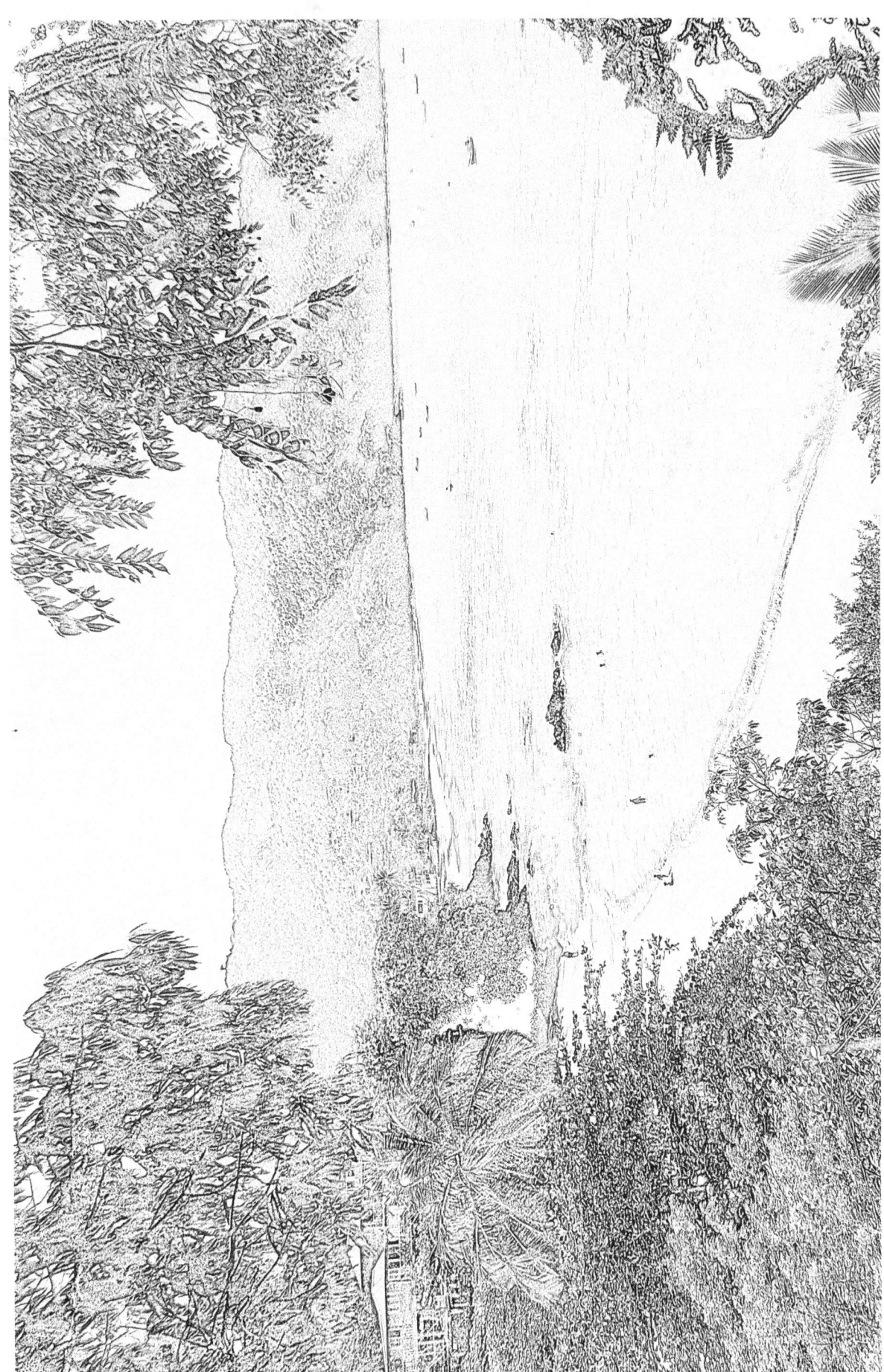

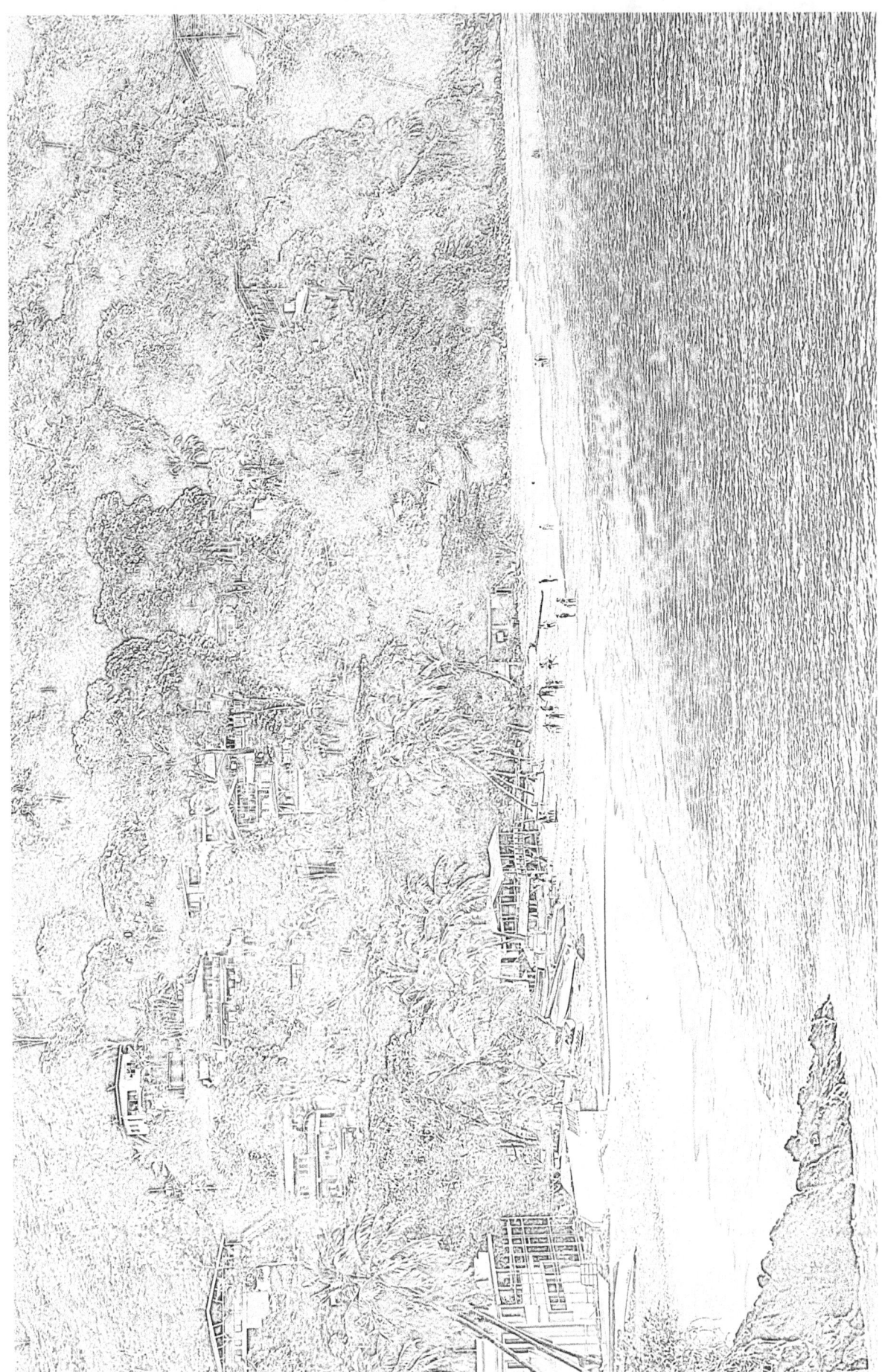

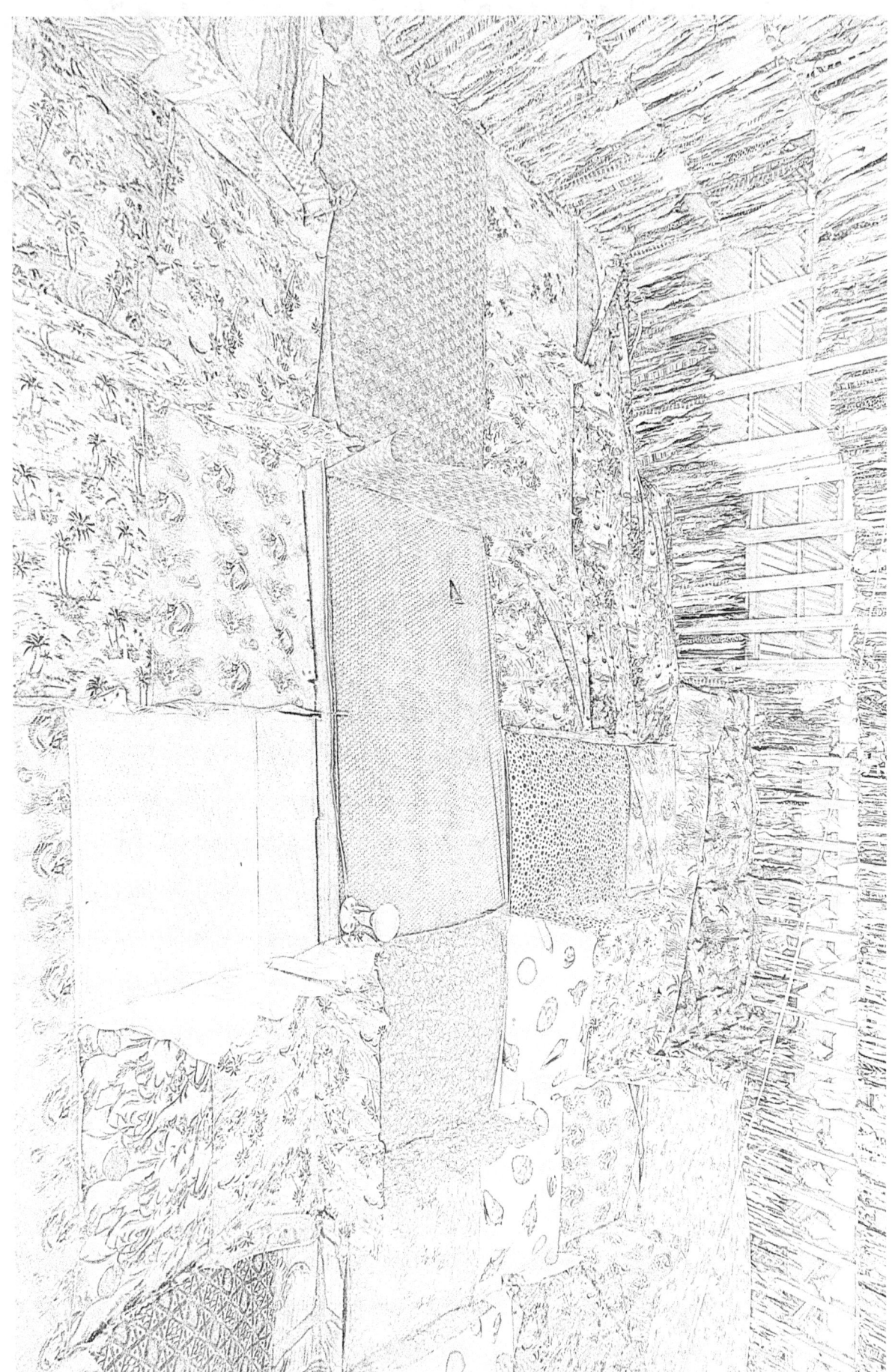

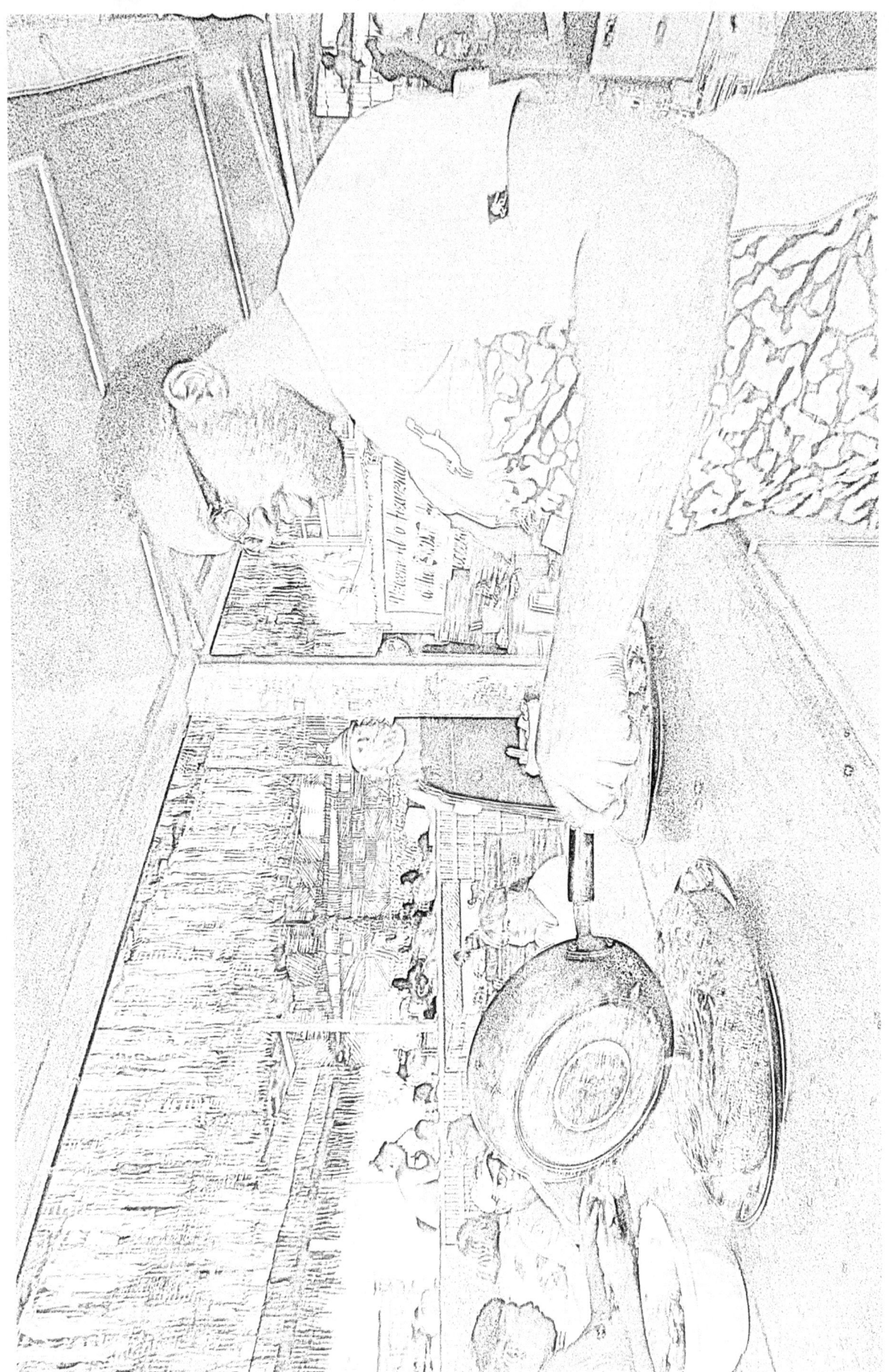

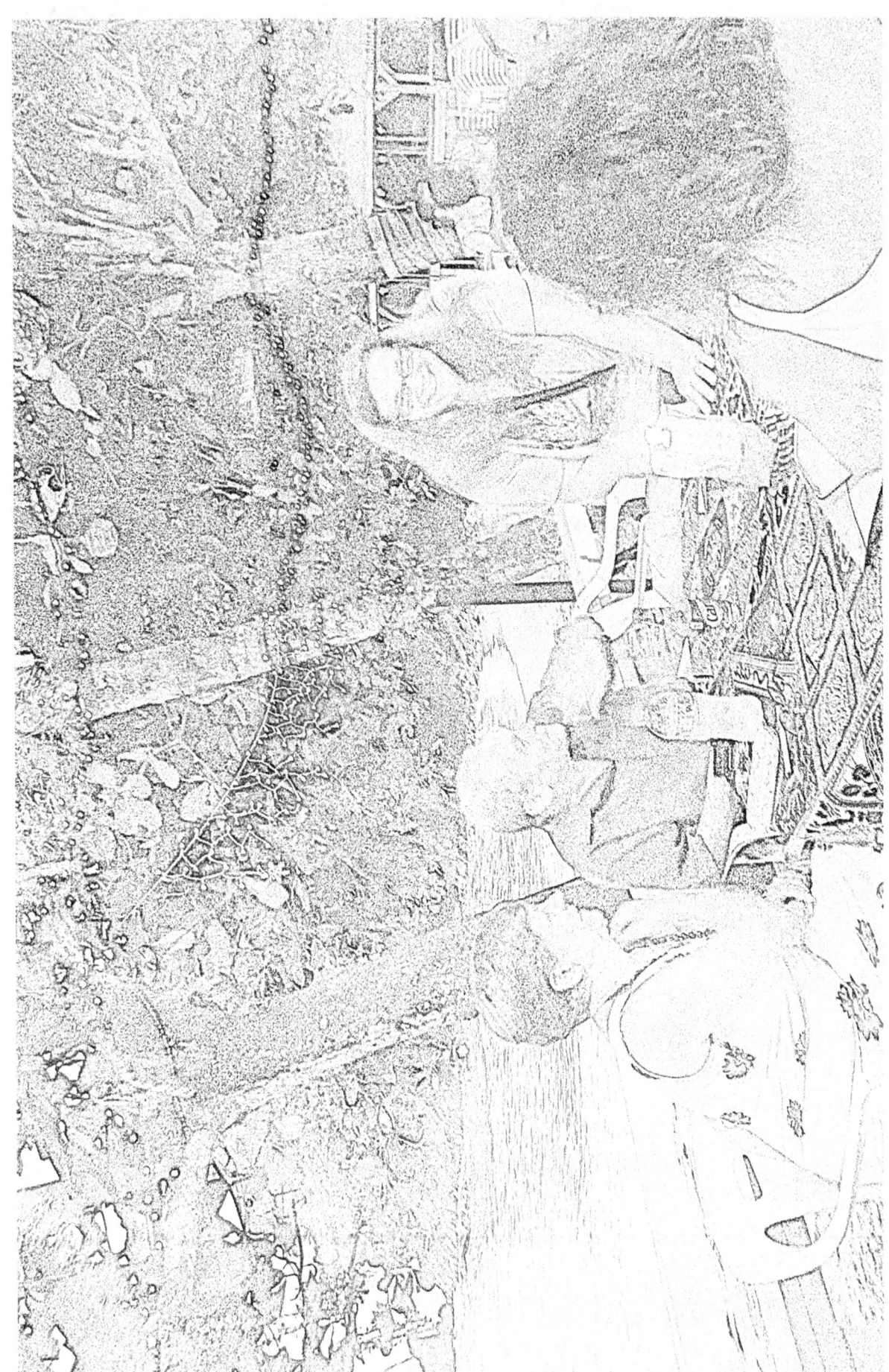

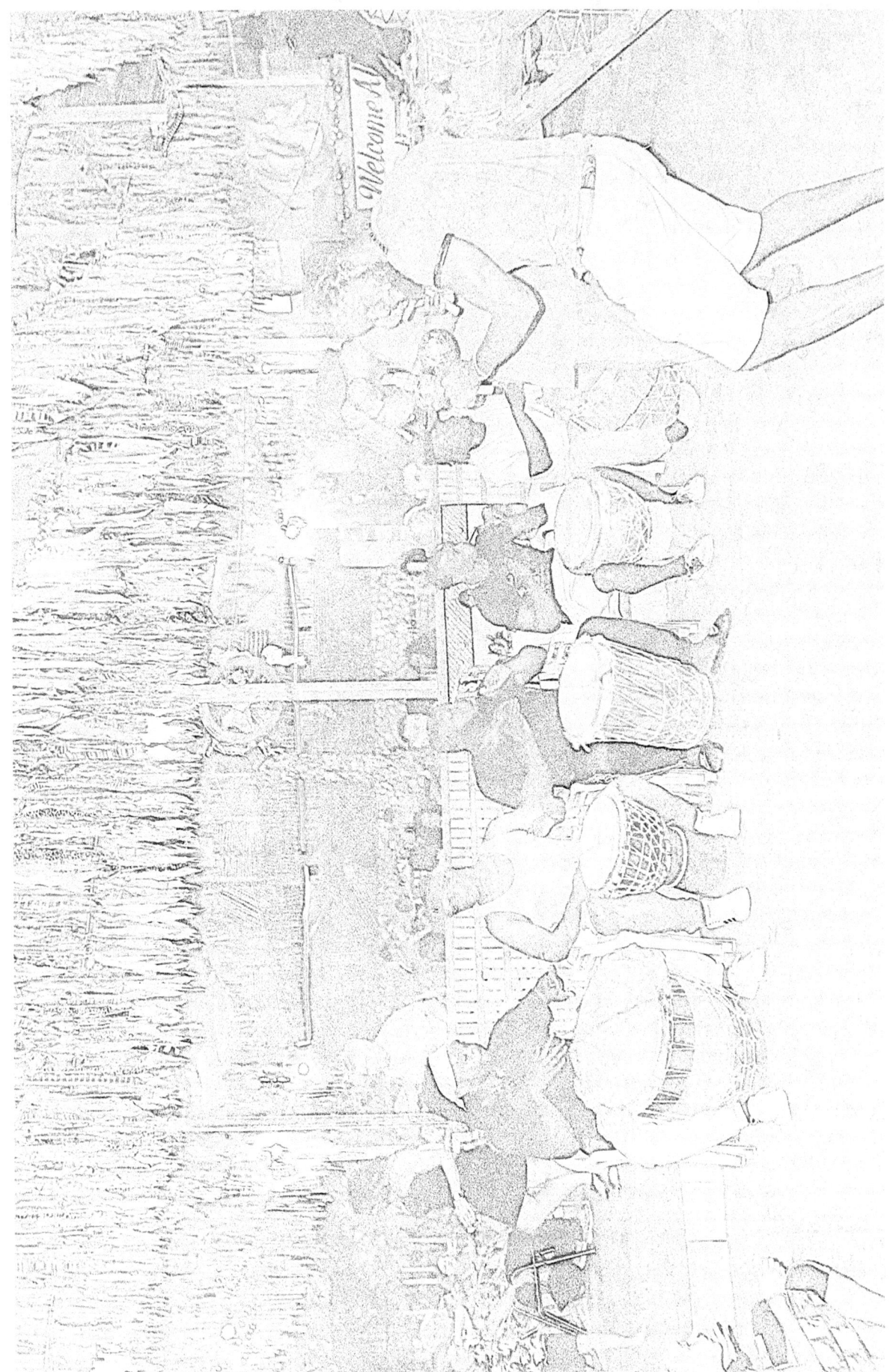

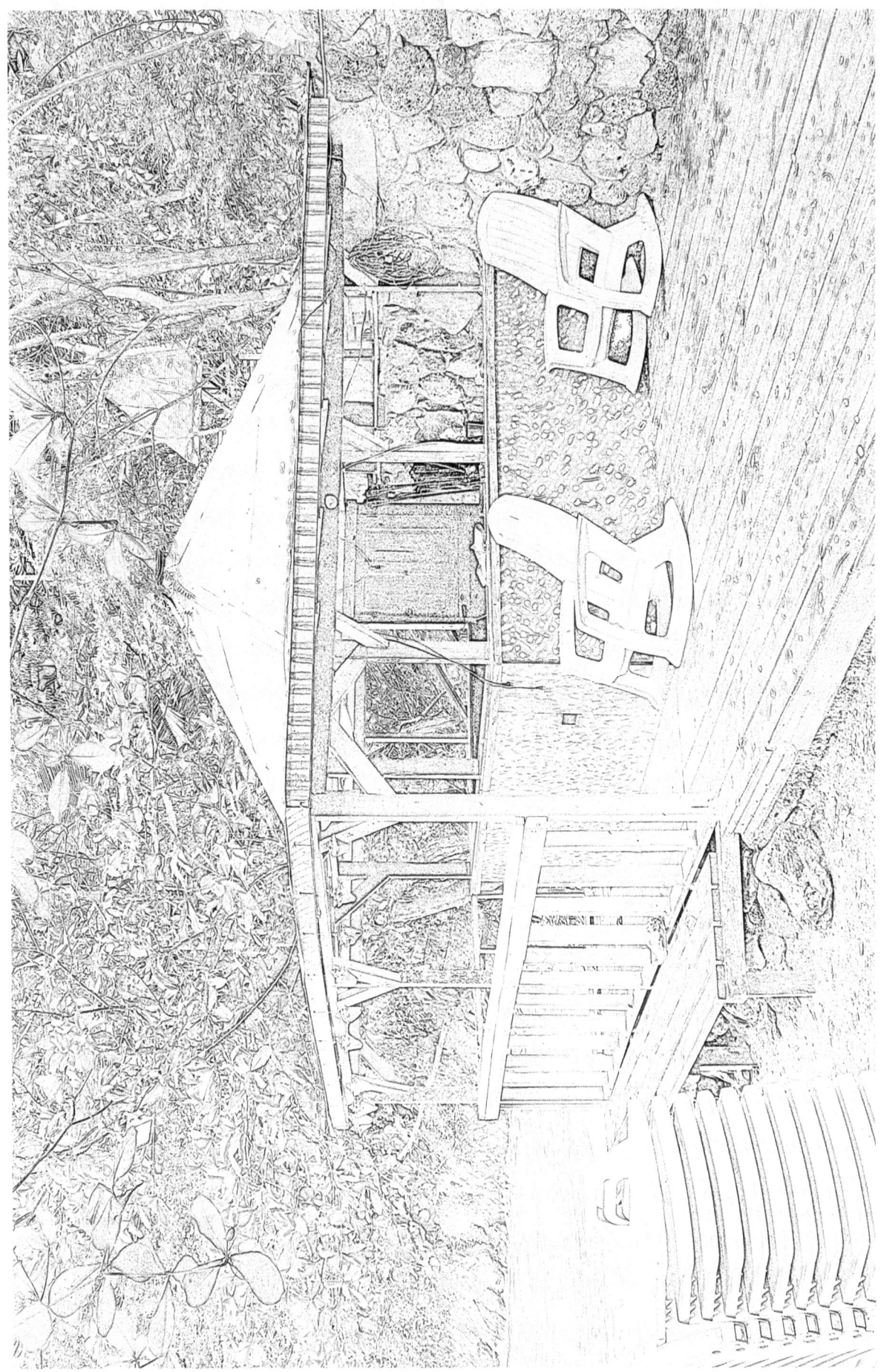

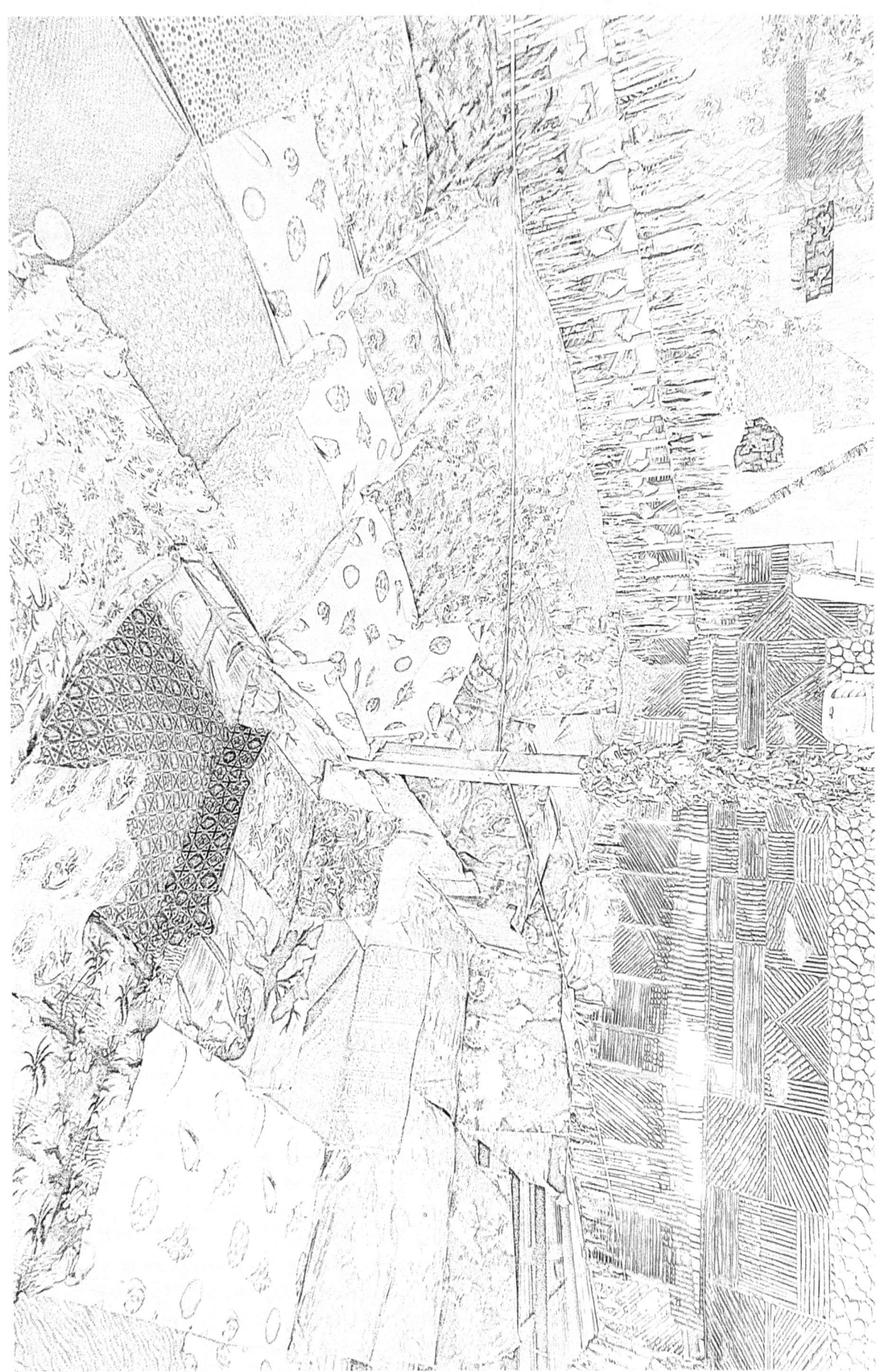

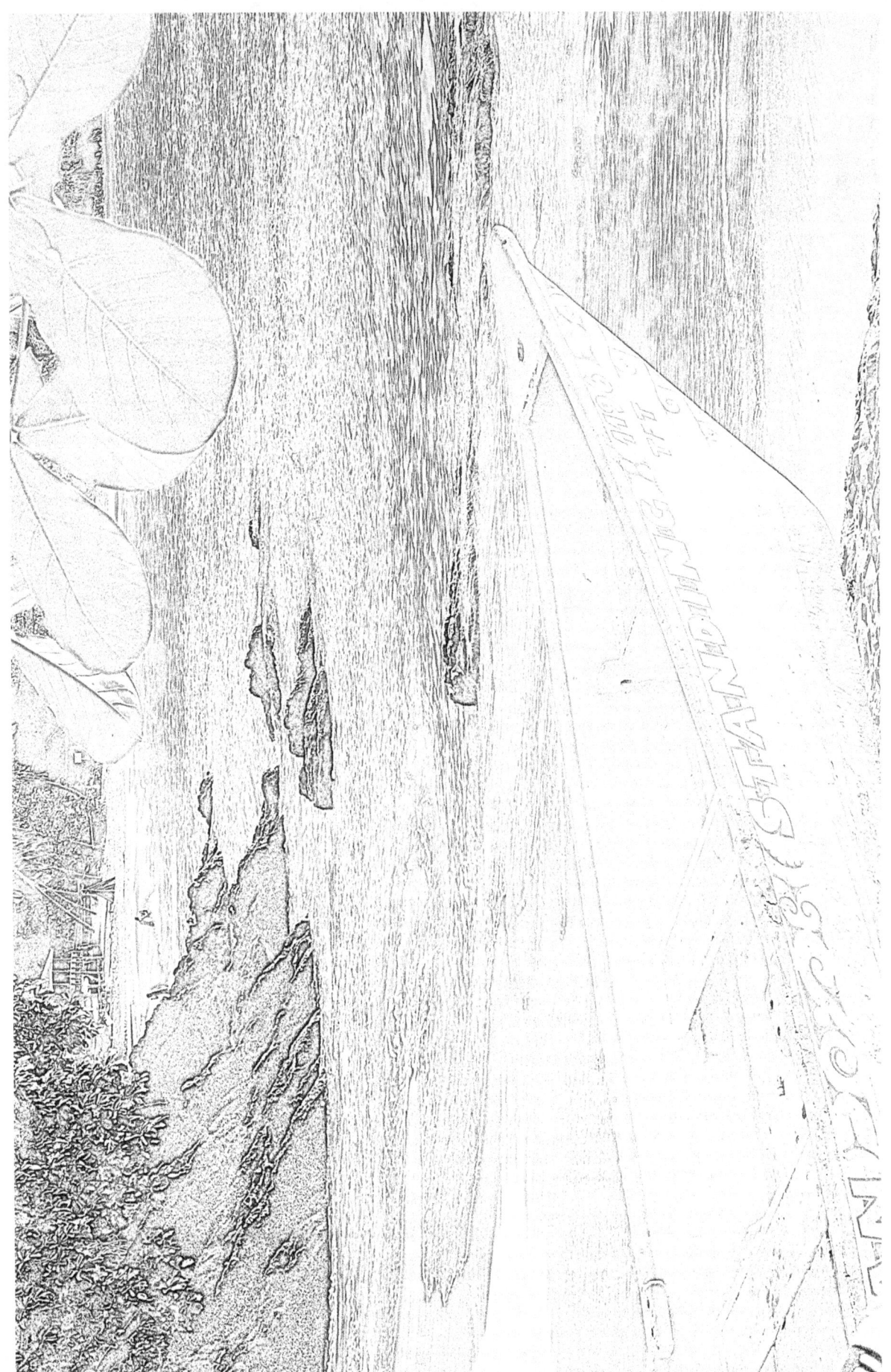

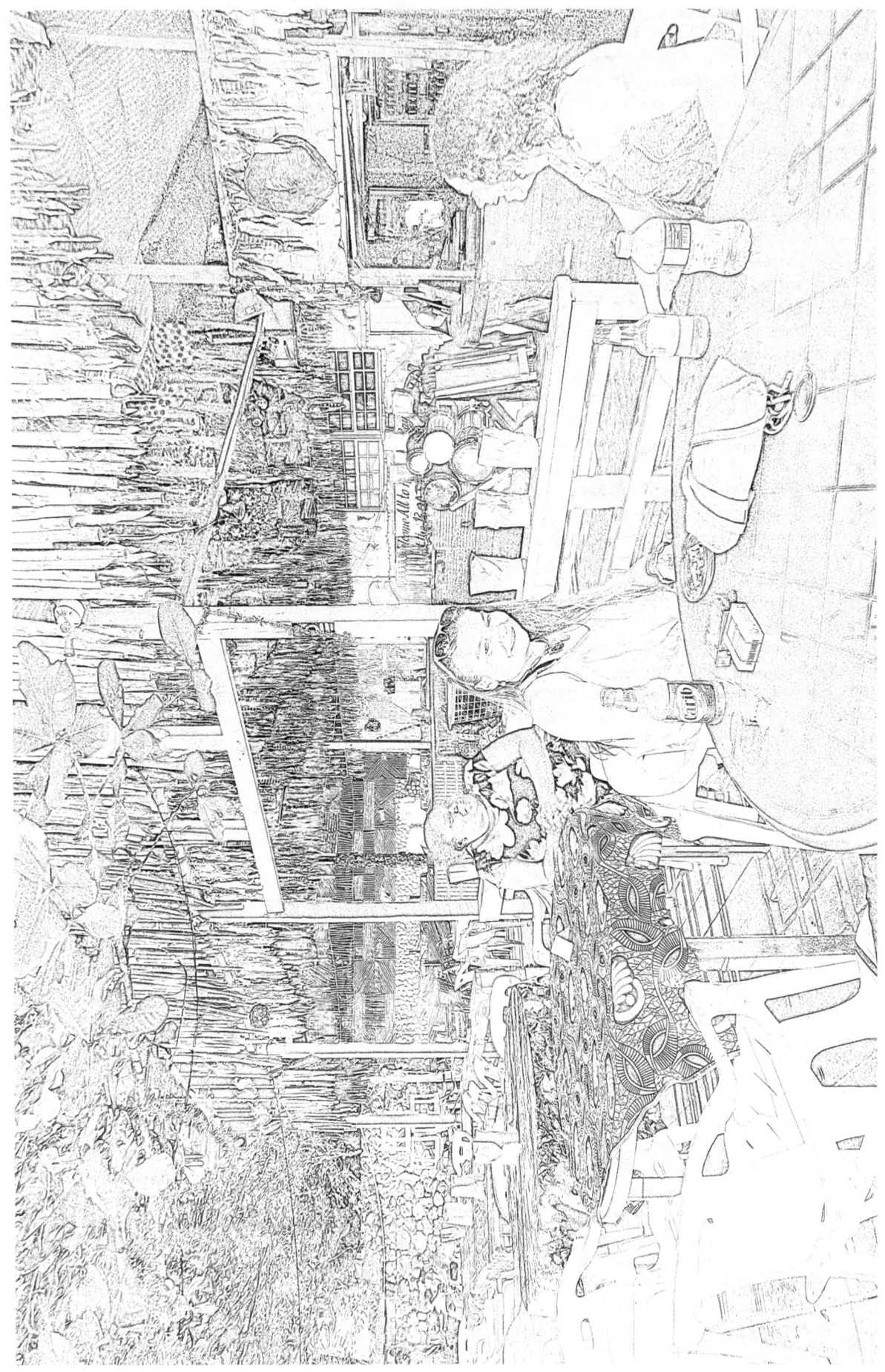

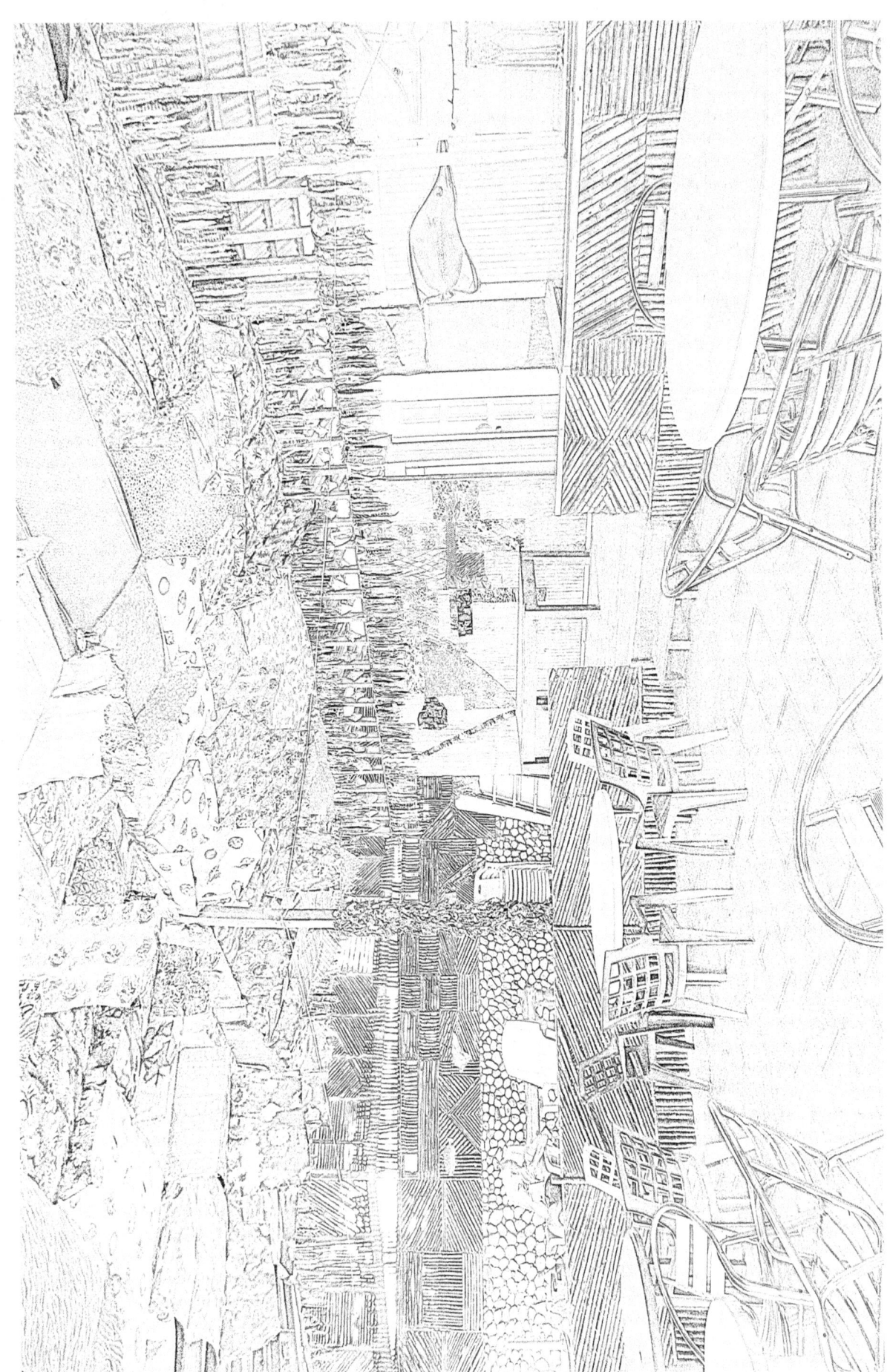

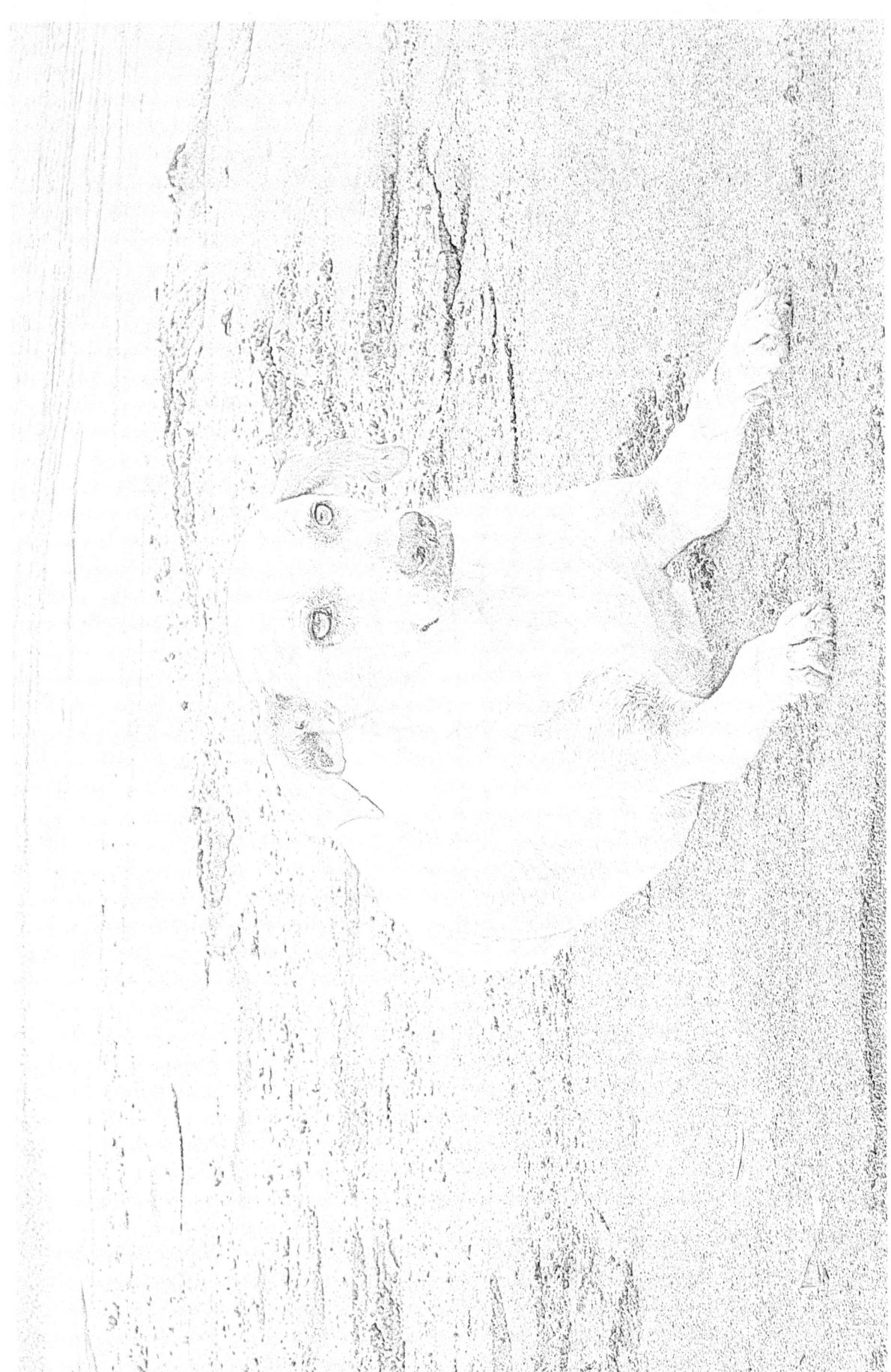

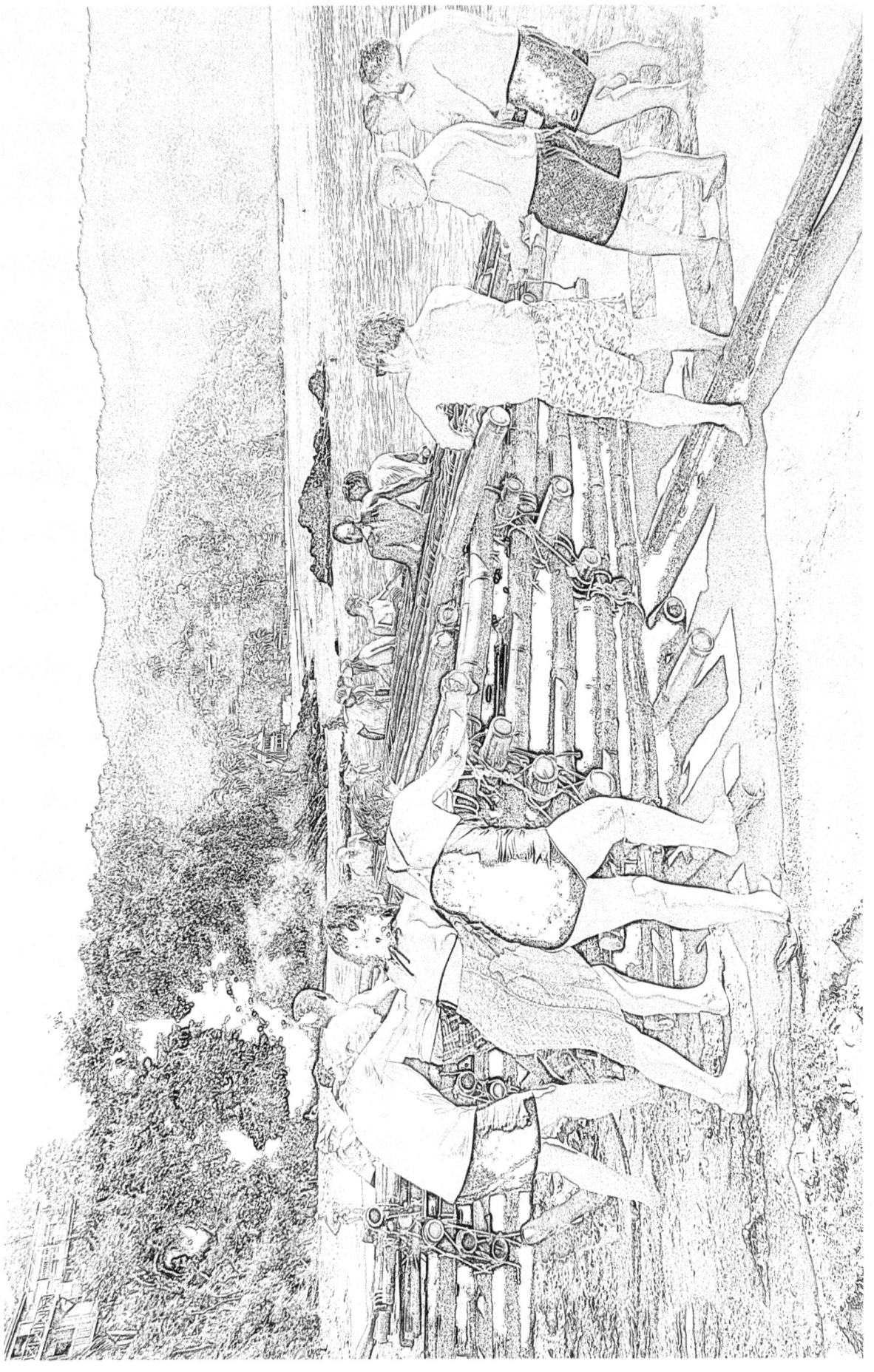

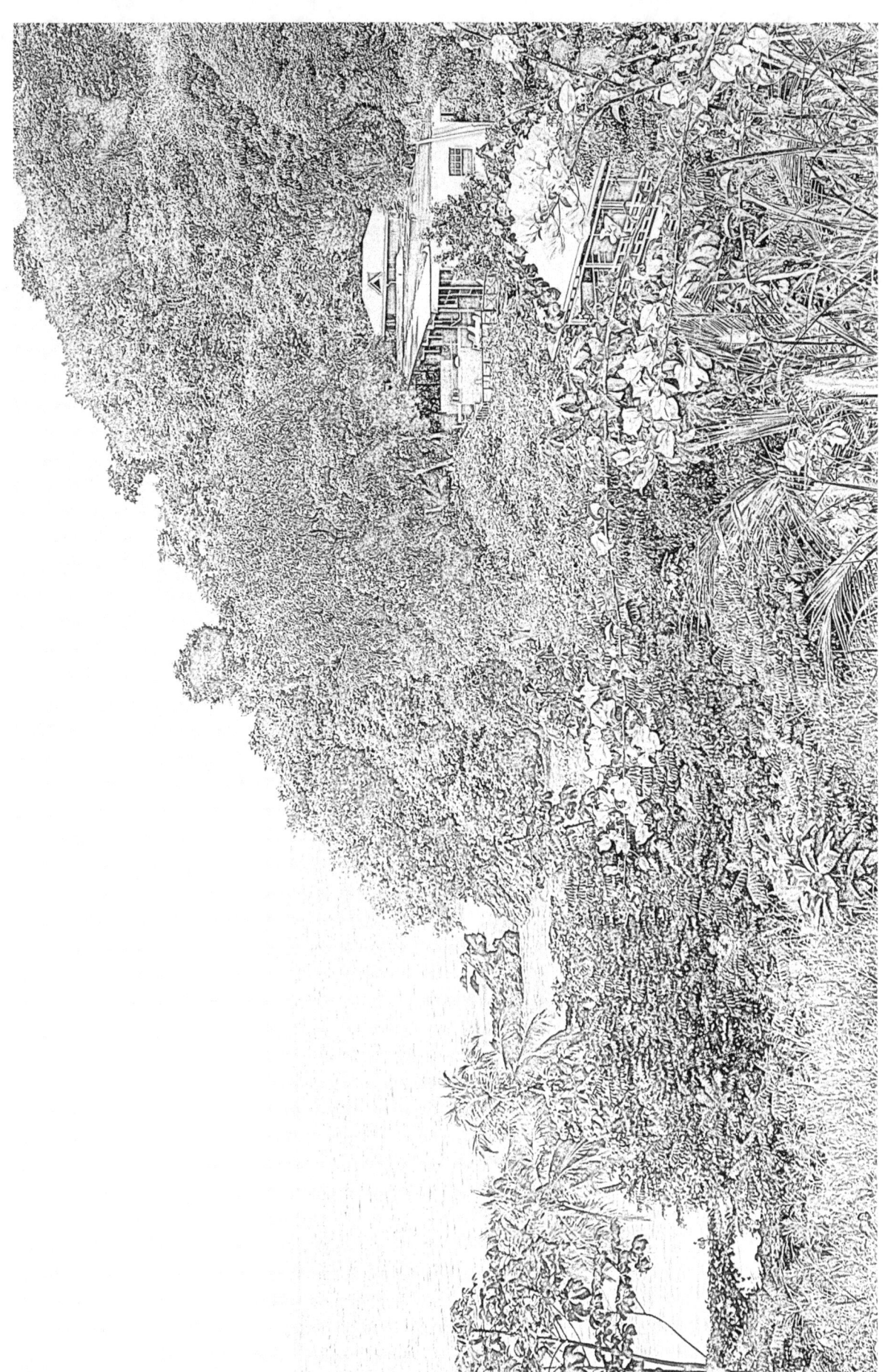

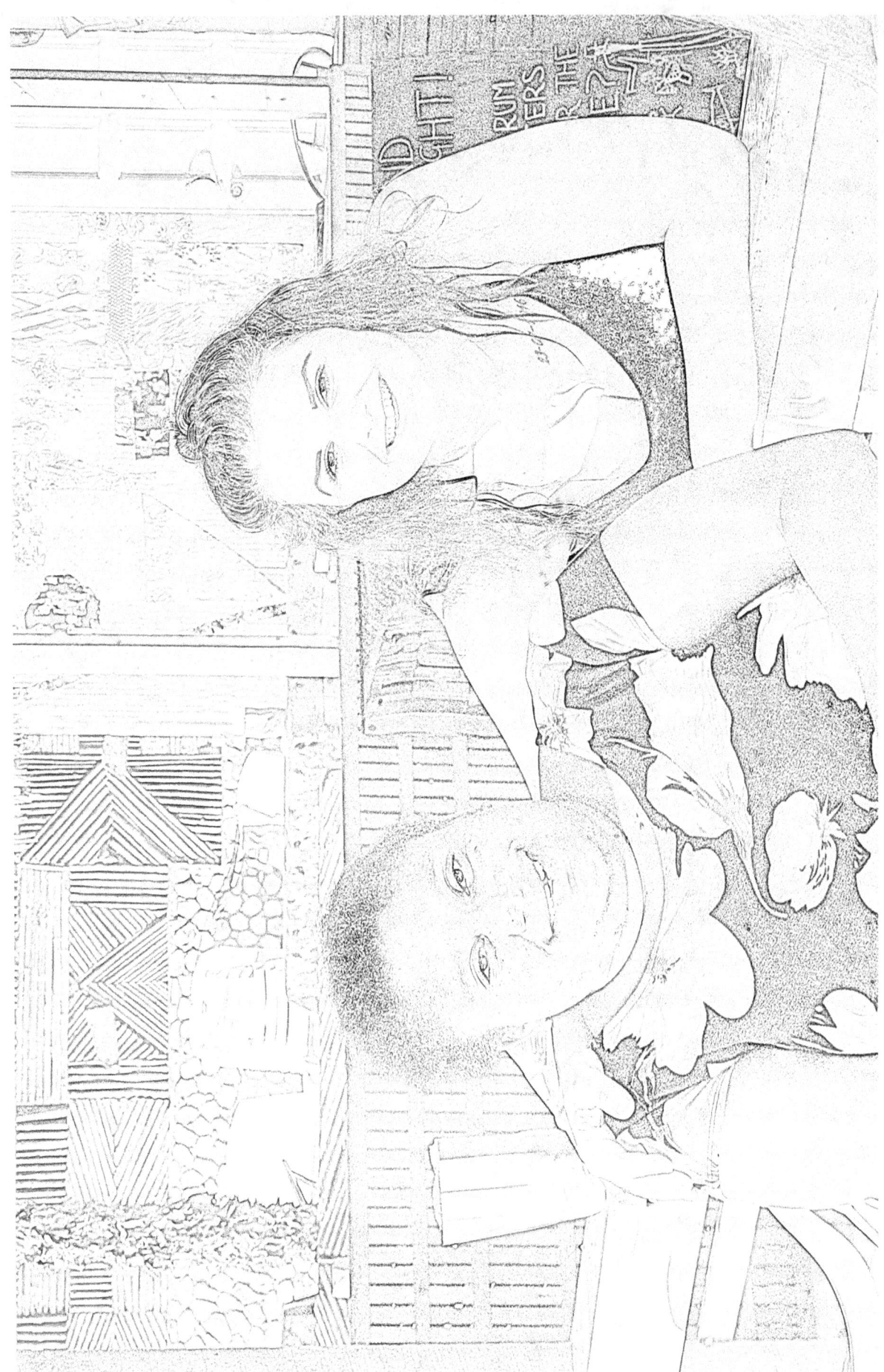

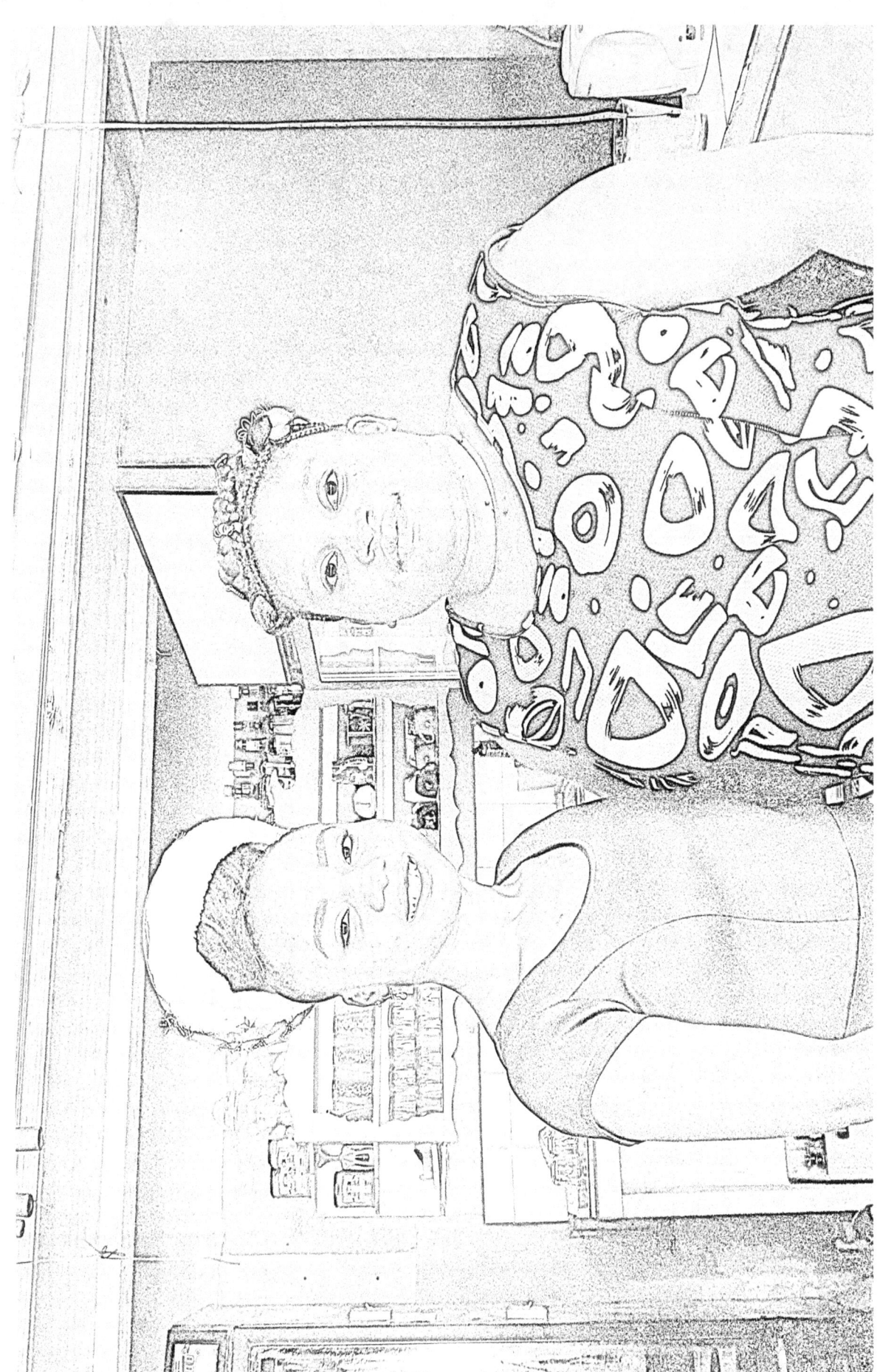

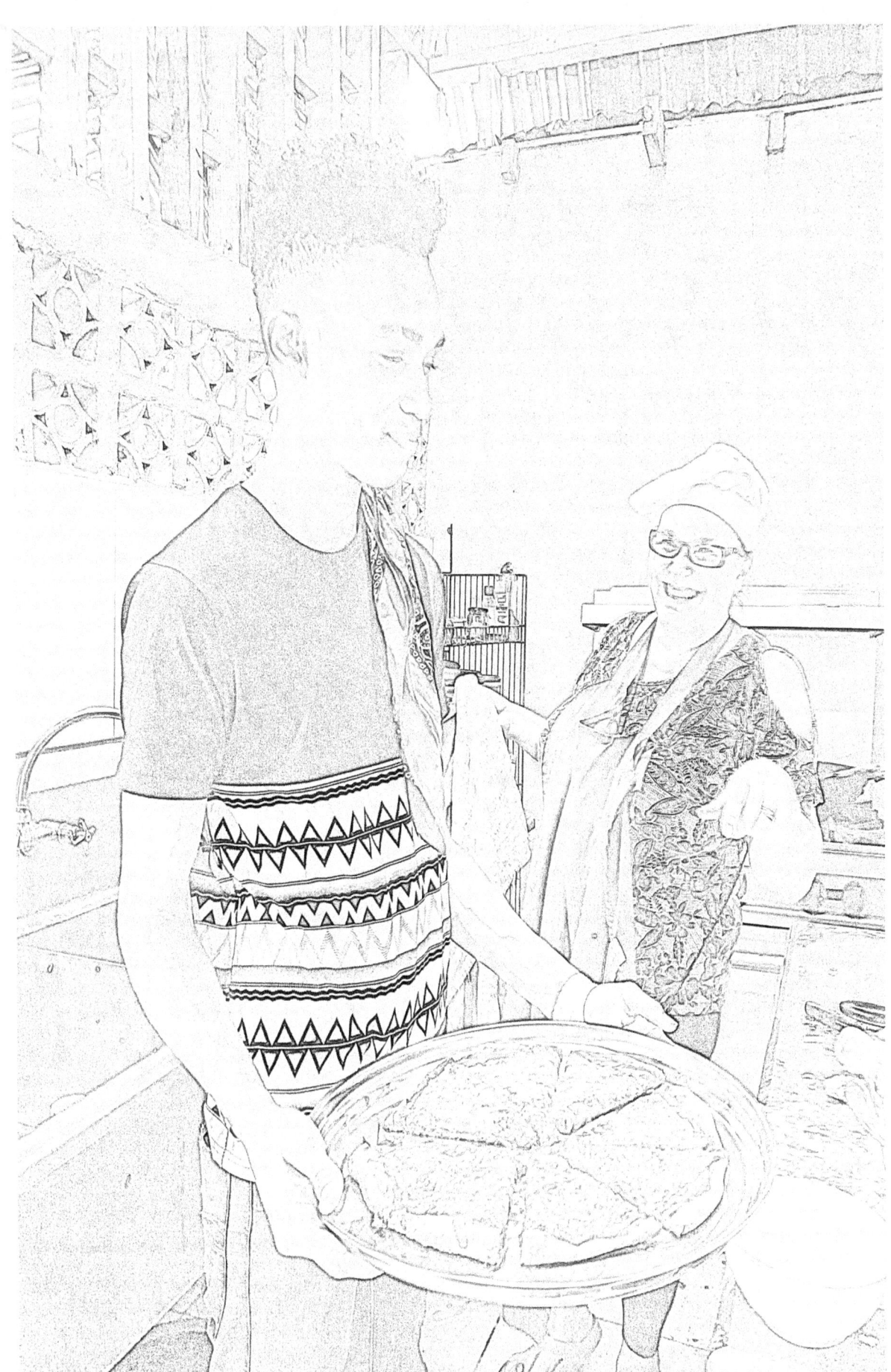

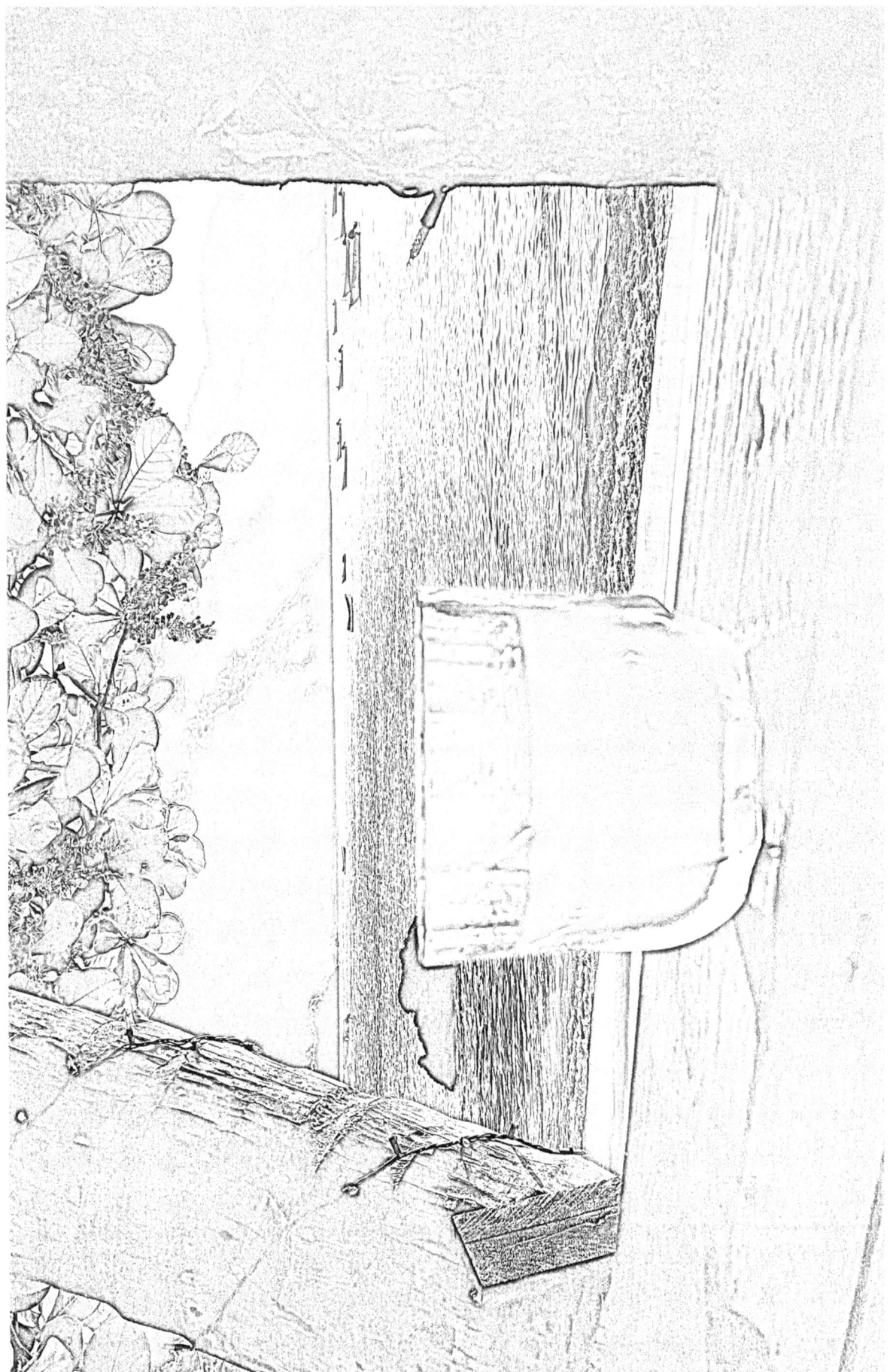

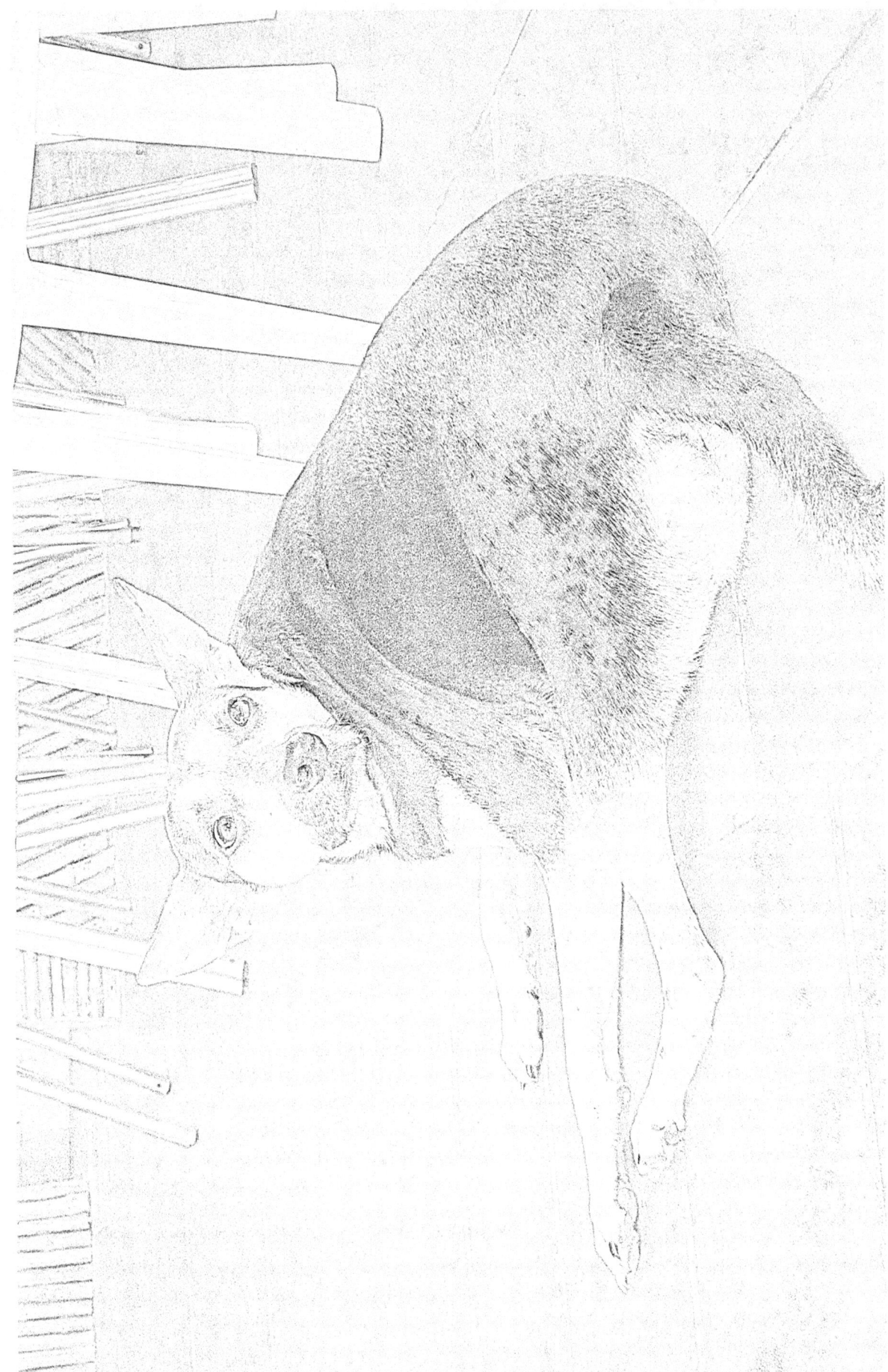

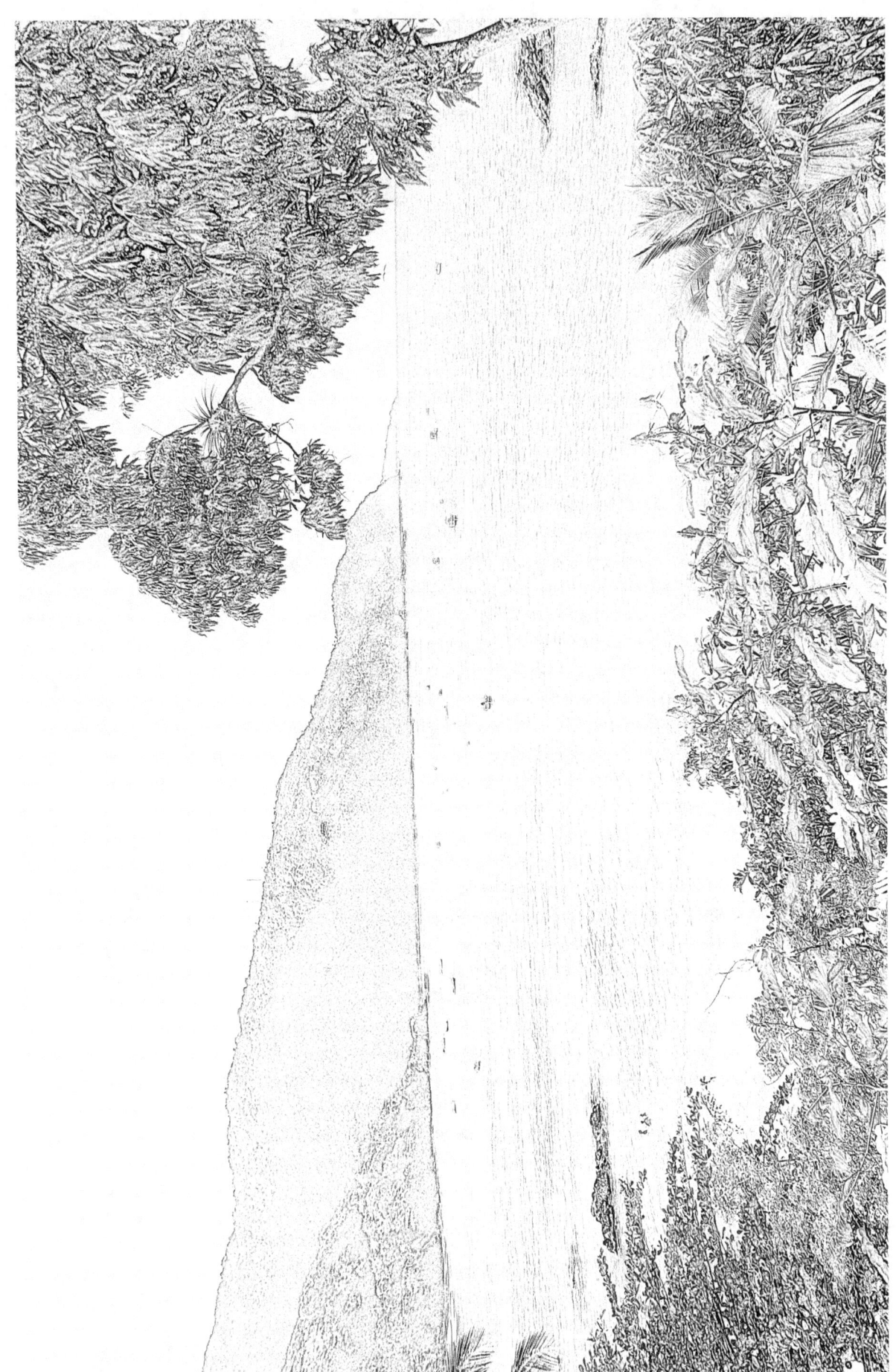

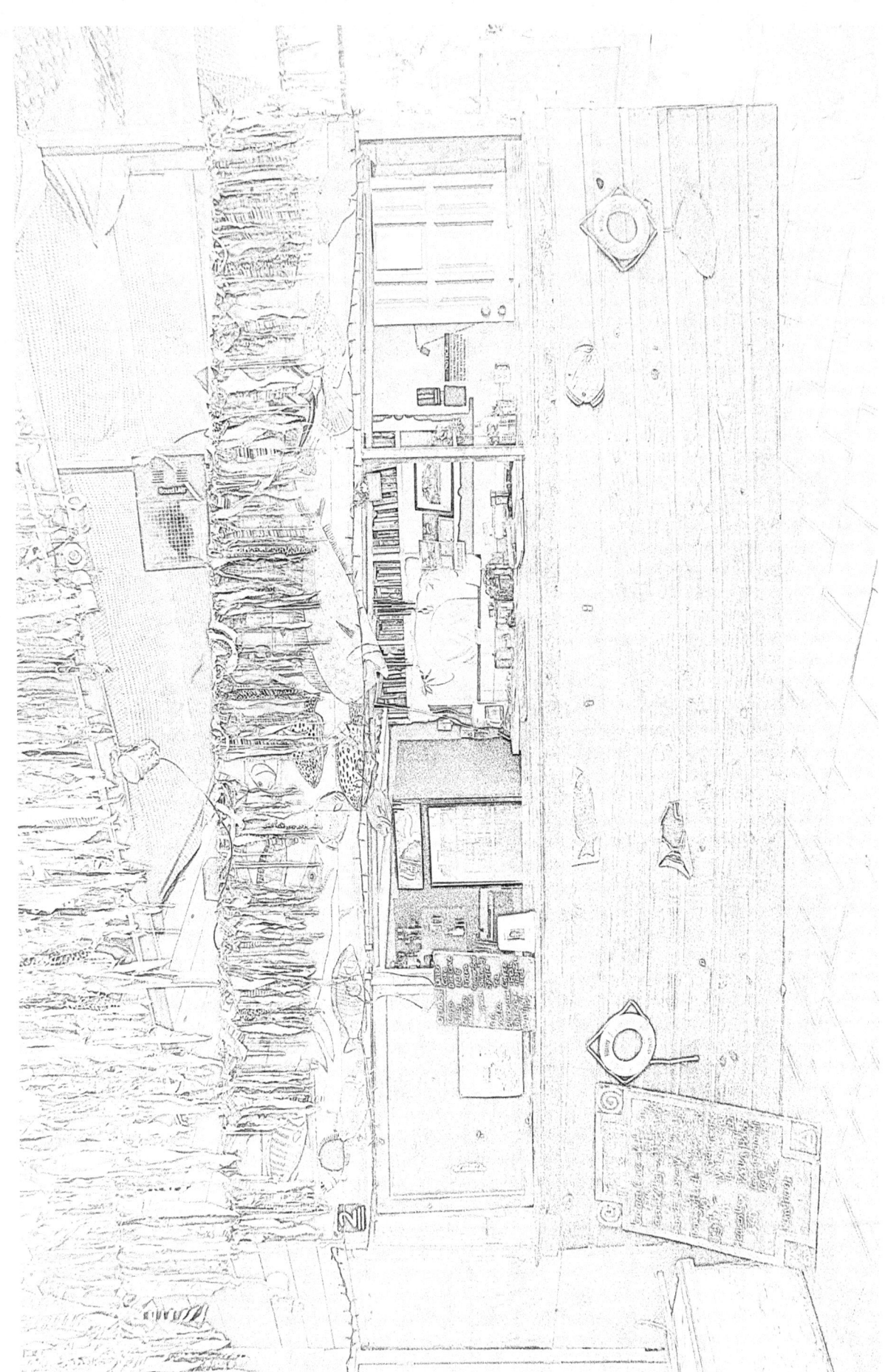

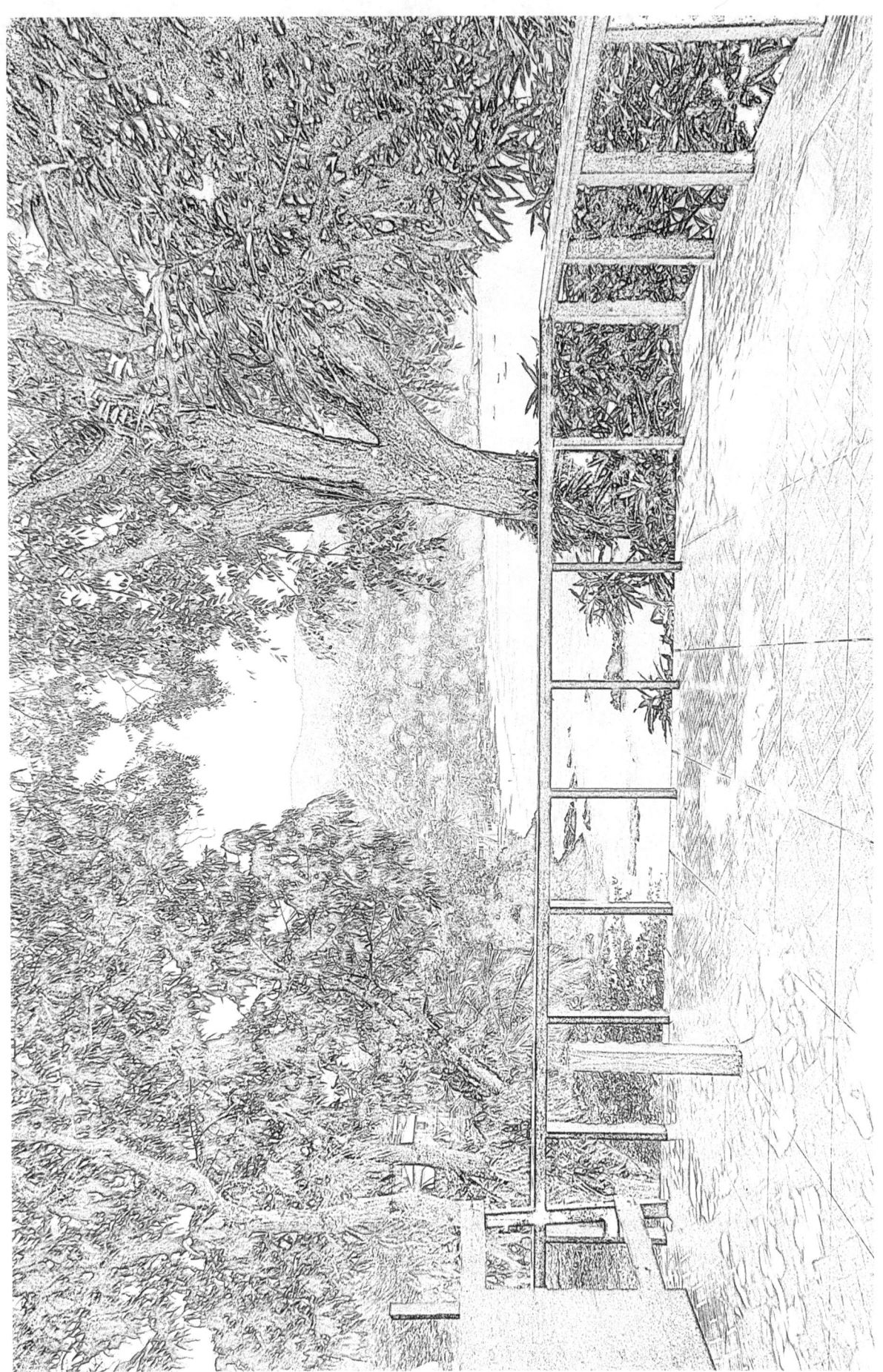

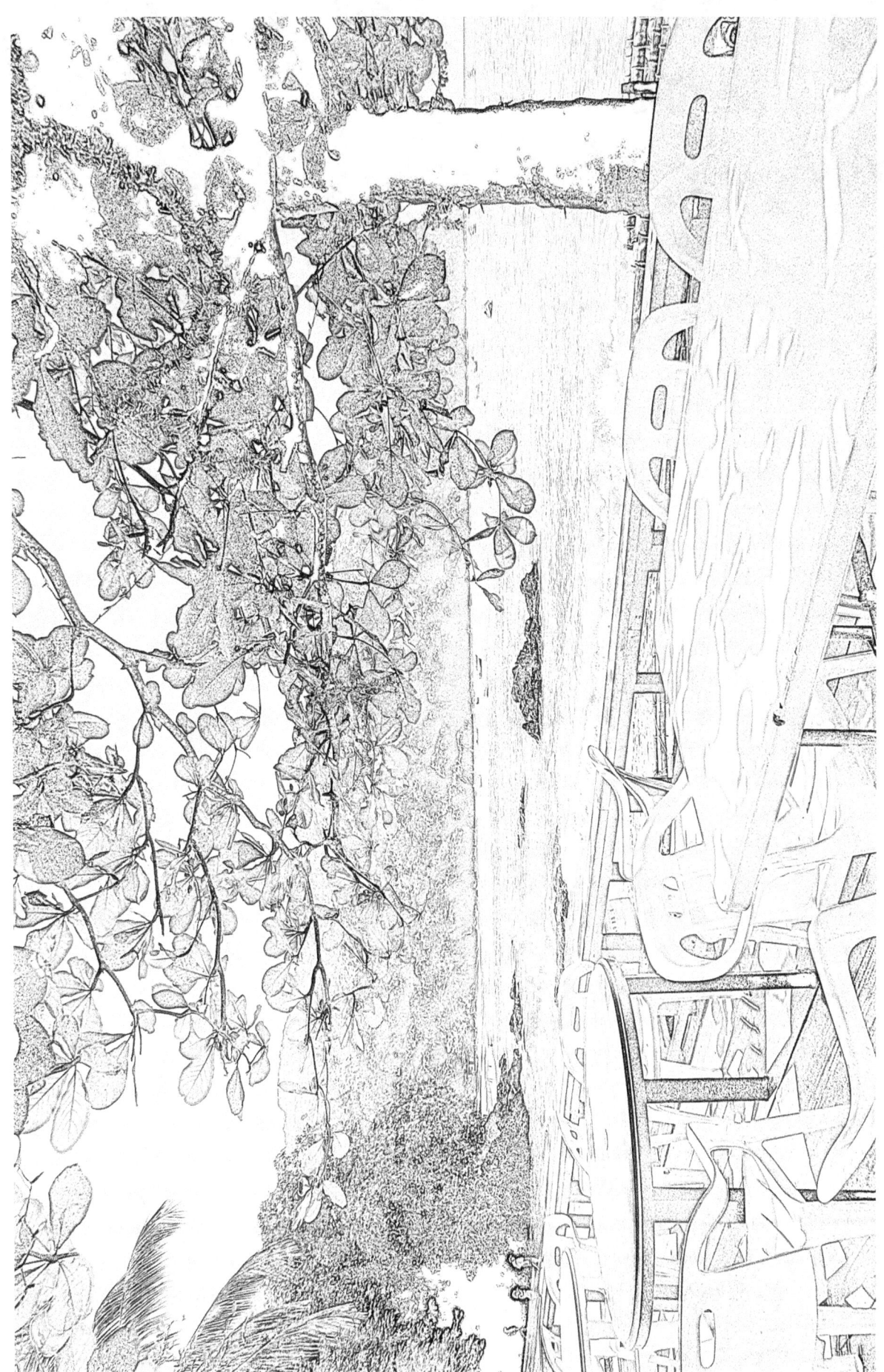

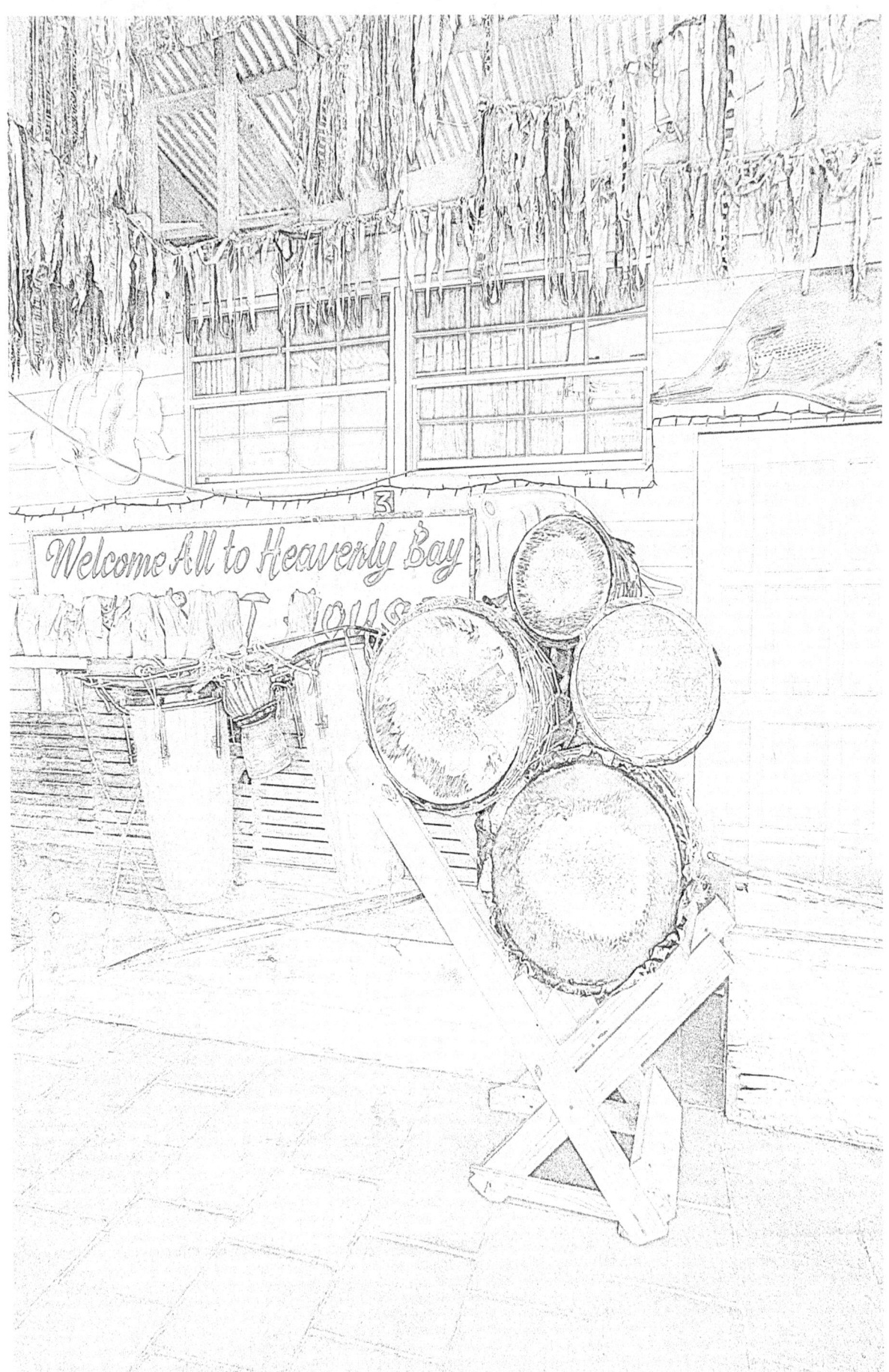

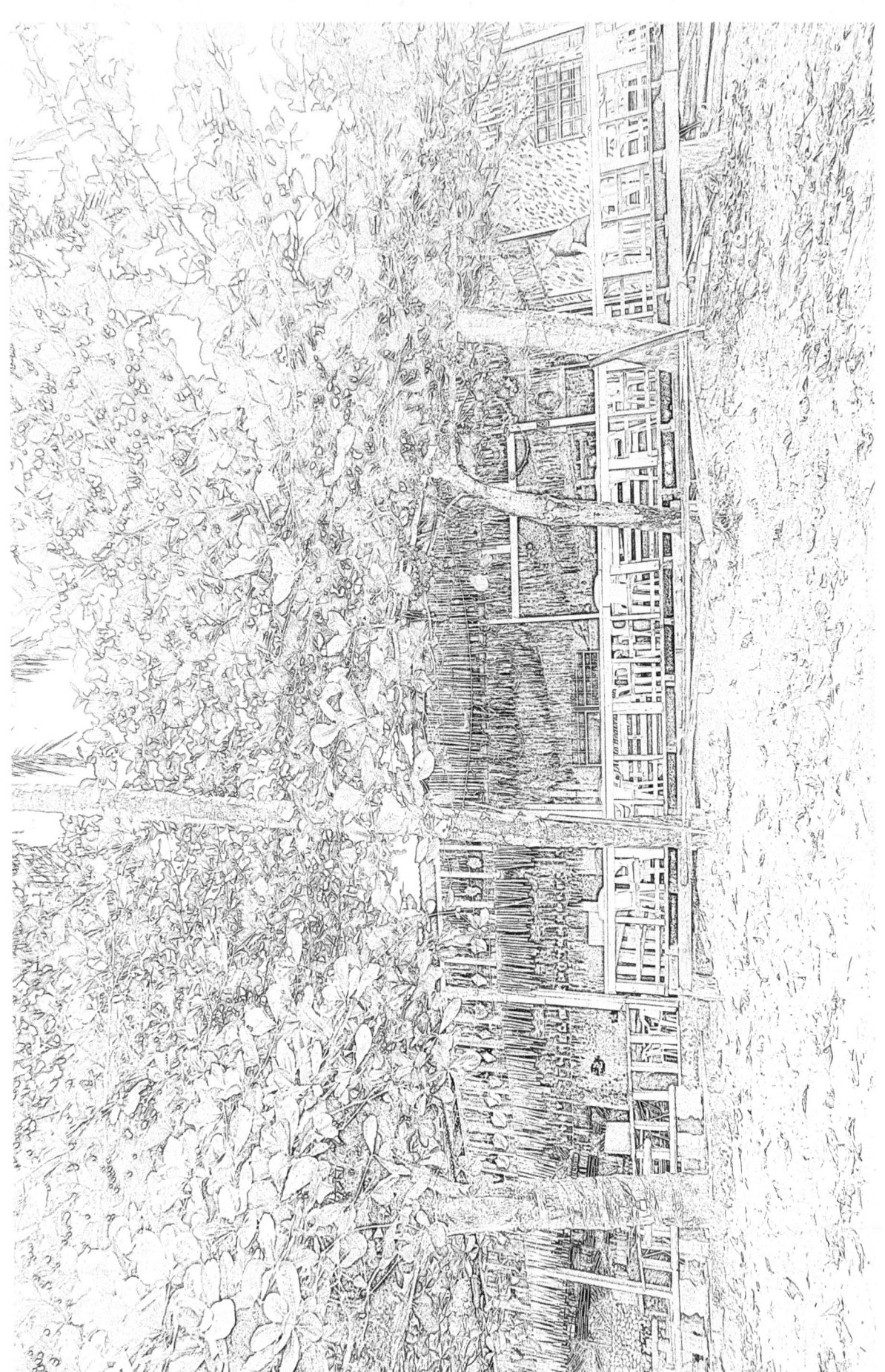

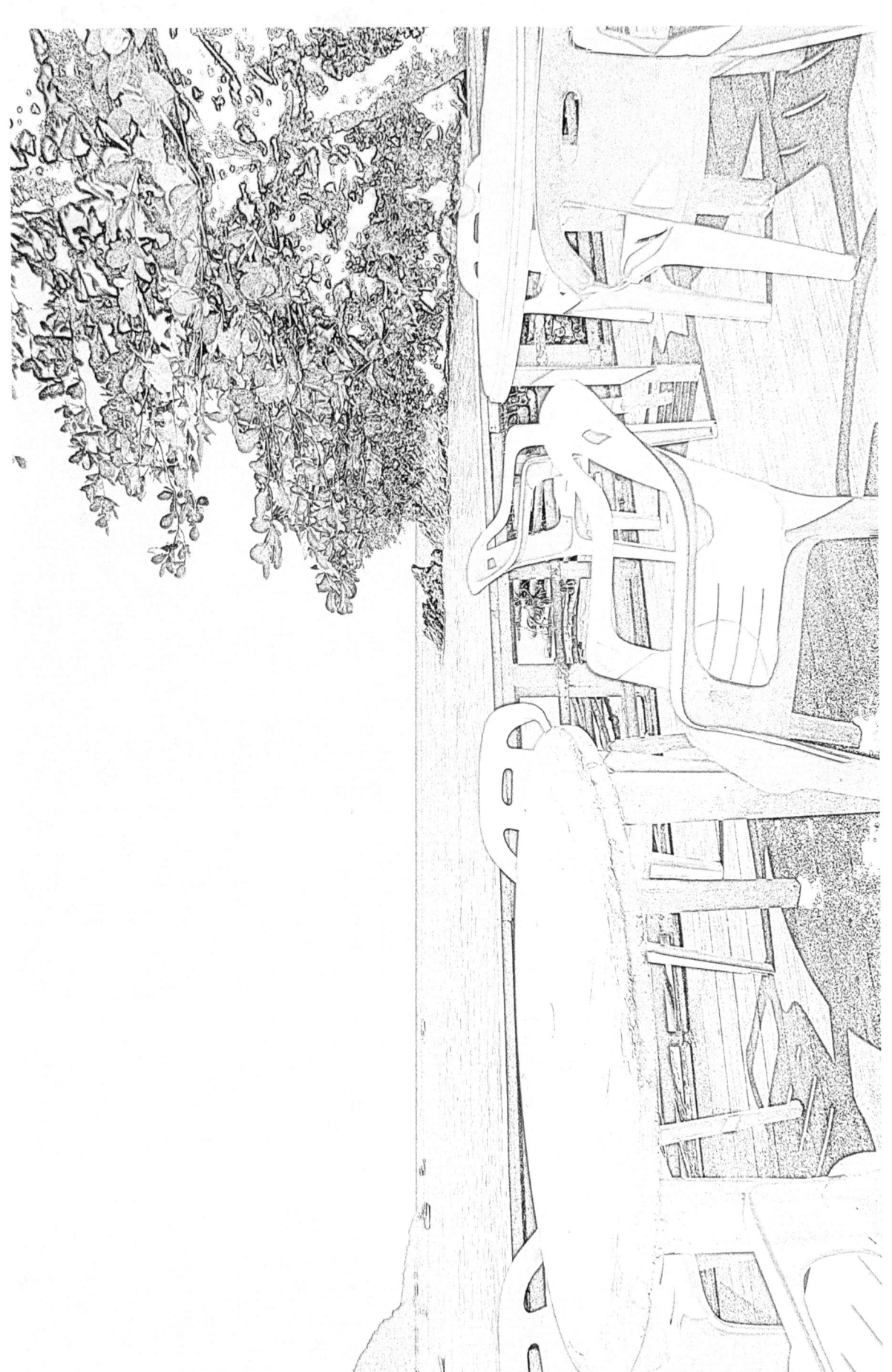

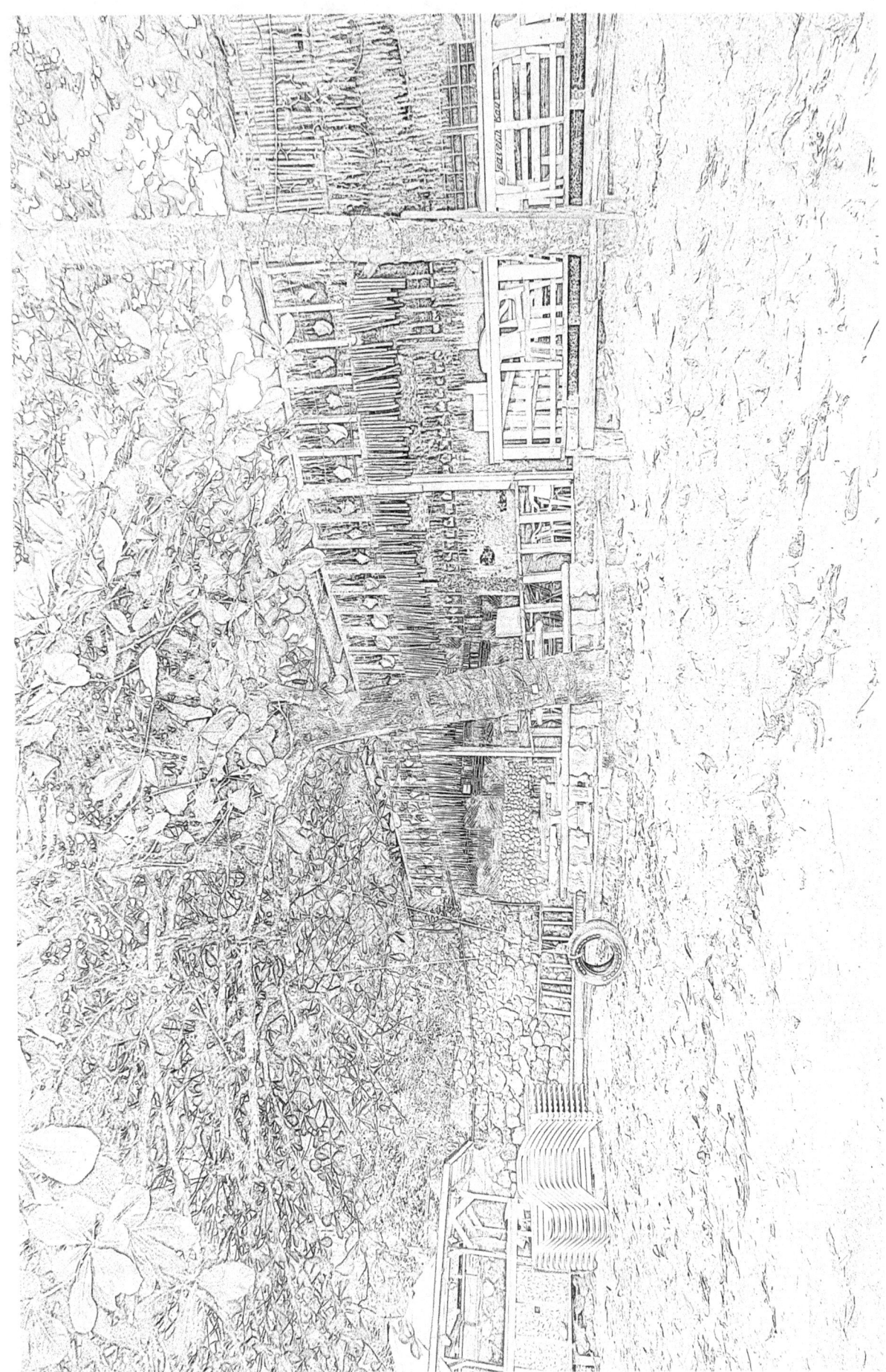

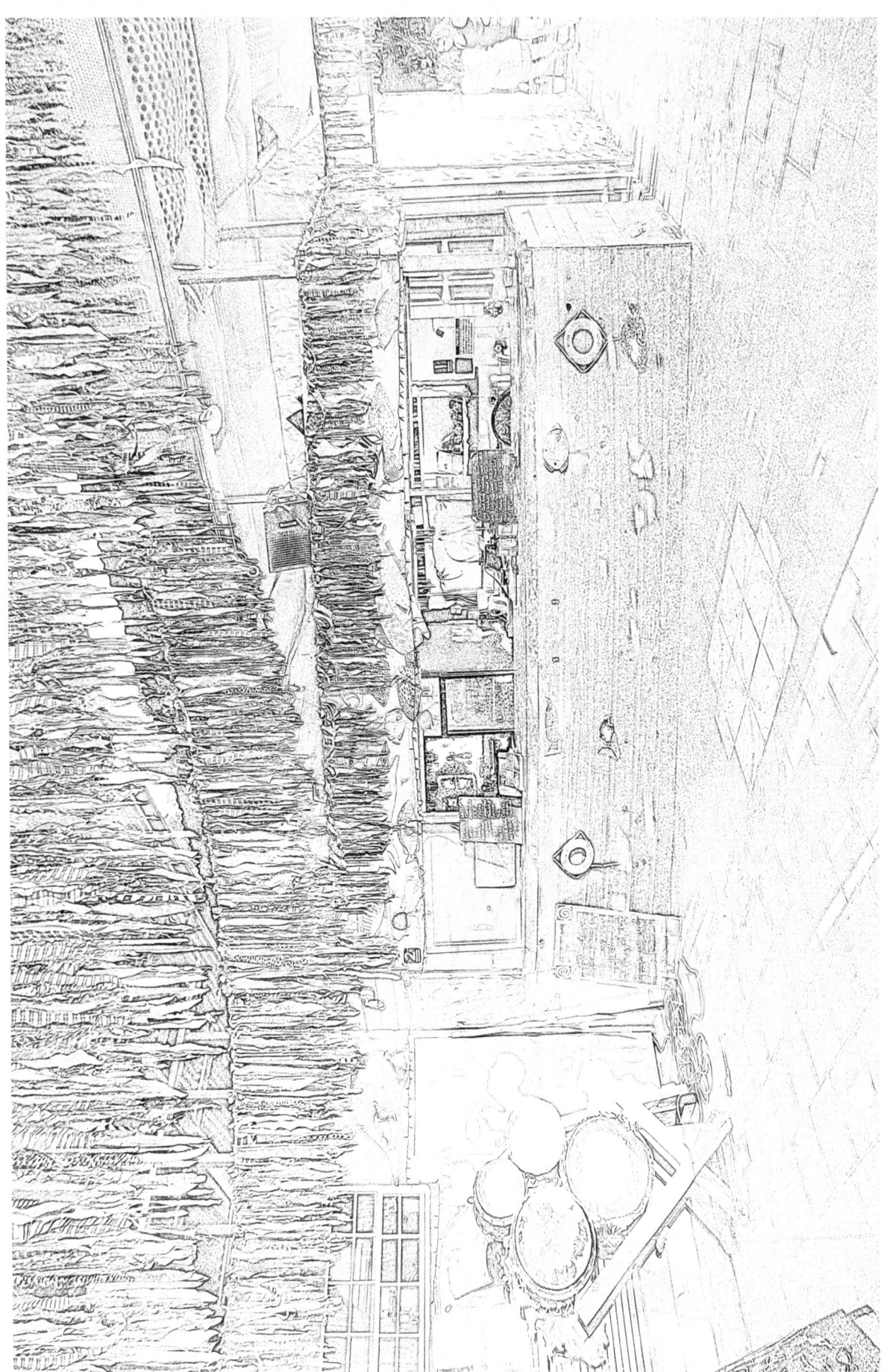

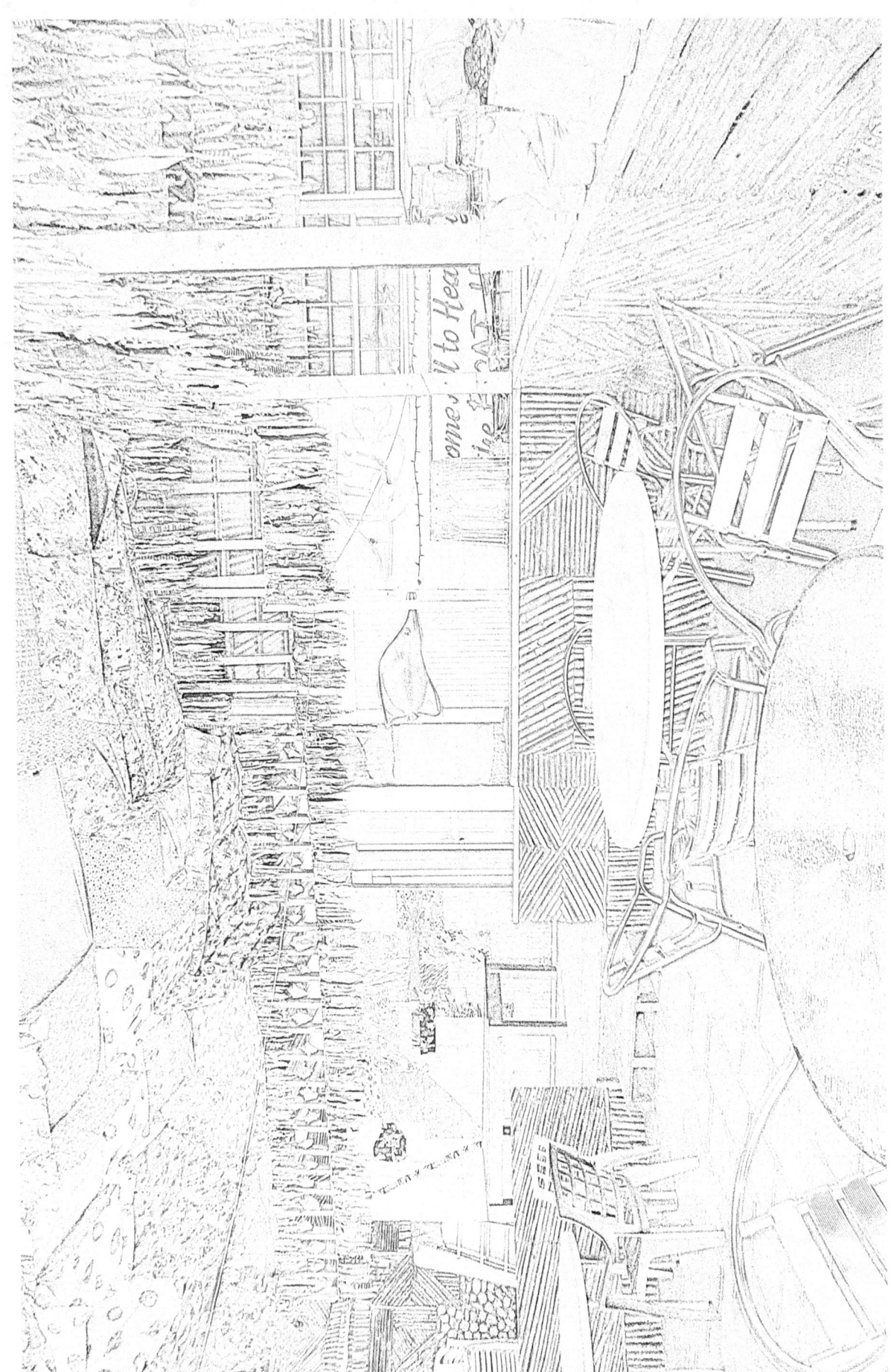

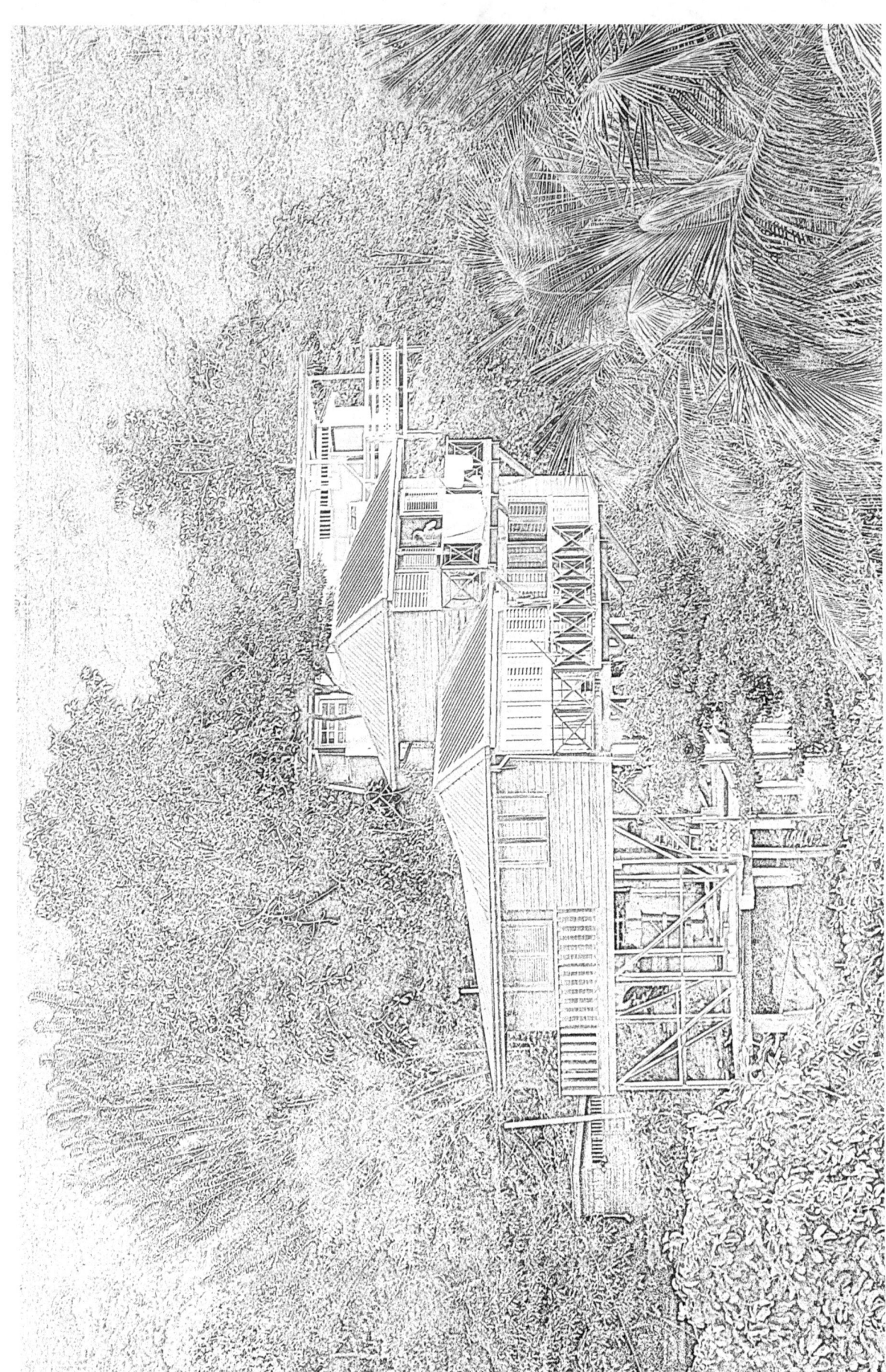

www.ingramcontent.com/pod-product-compliance
Lightning Source LLC
Chambersburg PA
CBHW080903220526
45466CB00011BA/3457